CW00541477

THE NEW ART

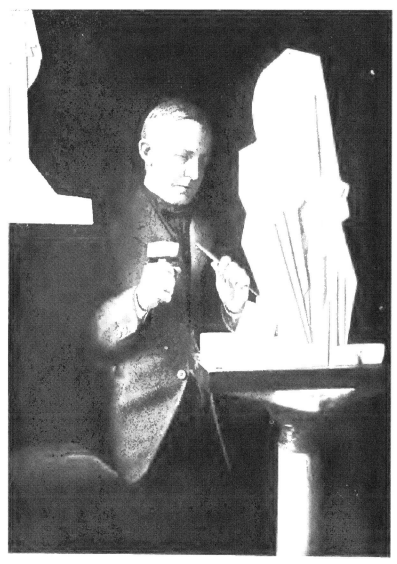

LAWRENCE ATKINSON.

THE NEW ART

A Study of the Principles
of non-representational Art
and their application in the
work of Lawrence Atkinson

BY

HORACE SHIPP

LONDON :

CECIL PALMER, Oakley House, Bloomsbury Street, W.C. 1.

CONTENTS

A PRIORI : '
Twelve Principles of Art Criticism

PART ONE :
The New Art in Theory : A Study of its Tenets and Philosophy.

PART TWO :
The New Art in Practice : The Art of Lawrence Atkinson.

LIST OF ILLUSTRATIONS.

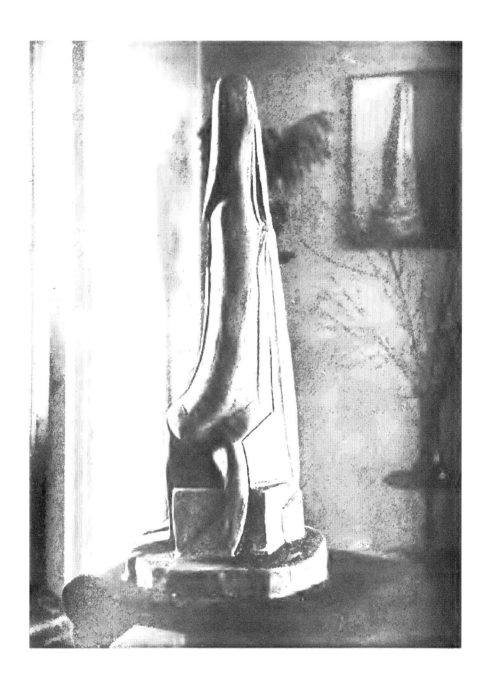

A Priori

I.

The Artist can choose his own path ; his work must be judged by the standards implicit in it.

II.

At this stage we no longer need merely to assert the existence of things by representing them ; art serves the deeper purpose of revealing the elements which go to their formation, and their spatial and other relationship to their environment and the human mind.

III.

Aristotle or Plato ; analysis or synthesis : objects or ideas about objects : detailed representation of an individual thing or presentation of the universal type. Science and the camera can give us the one ; philosophy and art the other.

IV.

Representational art is nature seen through the lens of the eye : the new art is nature seen through the lens of the mind.

V.

A work of art may tell a story, state a fact, boast an artist's technical skill, or reveal a belief. It may achieve all these, but the artist has the right of choice if he prefers to eliminate any phase for the sake of emphasising another.

VI.

All art is the selection of symbolic essentials.

VII.

Great art, says Walter Pater, approximates to the condition of music. We do not ask that a musical composition should sound like anything outside itself. Its appeal is not to the comparative of the conscious intellect, but to the superlative of the subconscious emotions.

VIII.

Abstract form is the embodiment of an artist's ideas about a thing, freed from the re-iteration of its concrete appearance, thus revealing the more intensely the dynamics which went to its creation, the laws which govern its existence, its structional and emotional interest, and by these means the significance which it has in the scheme of the universe.

IX,

The " Thing " presented may have no concrete existence outside the artist's mind until he creates it.

X.

Beneath the accidentals of individual *surface* lie the universals of basic *form*—the factor which governs the relationship of part to part, of part to whole, and of the whole object to the universal environment of which it forms part.

XI

Aesthetic pleasure is our joy in this assurance of a universe harmonious beyond the power of accident, united in rhythm which finds echo in our own minds and feelings. It is our appreciation of the thinness of the veil between the finite and the infinite.

XII.

Appreciation of the new is no disloyalty to the old, rather is it the fulfilment of the promise of the old. All art is a quest for the ultimate truth about things, and the only real treachery is a refusal to continue the search.

The Theory of the New Art

A STUDY OF ITS TENETS AND PHILOSOPHY

CHAPTER I.

The New Art

HERE has probably always been a "new" art; there has probably always been a struggle between its exponents and those who work on more accepted lines. Always, one imagines, the war of the schools has continued, and the practical work of the artists has led some men into the camp of the traditionalists, while a rebellious minority have raised other standards and fought for new ideals and ideas. Behind these practising artists and often more vociferous in their championship, have stood the thinkers and theorists of art, the critics; and behind them yet again, the public. At times the battle has raged around the work of one man whose truth to his own inspiration has led him away from the traditions and caused him to "fling his paint pot in the face of the public." At others it has been the work of a group united by some particular art method or philosophy which has challenged opinion and forced attention. Always the struggle has raged; always, no matter what the apparent and superficial aspect of the problems involved, the actual conflict has been the same: the art matter and manner accepted of that day and generation have been claimed to have achieved the last word in art, while the insurgents have refused such arbitrary limits and asserted the right of freedom and further search. One further phenomenon in this unceasing strife is that both forces invariably claim the art of the past as being evidence

in support of their respective titles : the one group emphas-
ising the static elements which remain in firm triumph at
the culmination of epochs, while the others with as great or
greater justification stress the transience from school to school
which has kept art vital and significant.

The thought of our time, largely under the influence of
Bergson, tends to appreciate the importance of the element
of eternal change rather than to insist upon the definite
points. It sees in the movement from one school of thought
to another a factor of greater importance than the achieve-
ment which in its very crowning of a tendency puts a
period to it. Even when movement is one to an opposite
extreme, a wide view of the progress of art or other activity
teaches us that it is part of the eternal unfolding and is not
a cancelling of the preceding idea or method.

If we are going to see creative work in a comprehensive
way, and appreciate at all fully its place and trend, it
becomes necessary that we should look at any particular work
and any particular school of art thought in this manner. It is
safe to say that no matter how individual a piece of art
is, it could not have come into existence without regard to
the thought environment of its period, and the evolutionary
process which has preceded its appearance. We tend, too
often to feel that any departure from the forms currently
accepted is anarchic—a throwing down of the earthworks
built by patient generations. Actually it is but another point
in that advance upon chaos and the night for the safeguarding
and assurance of which those earthworks have been raised.
All passes, nothing remains ; and yet, the essential thing is
eternal and cannot pass.

Study of a Figure in
relation to its environment

Water Colour Drawing

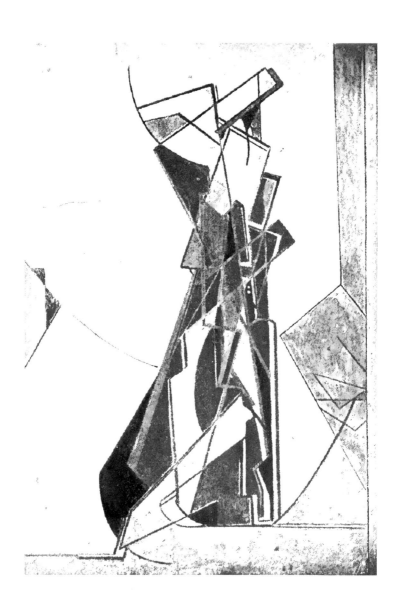

It is from this tendency to see only in part, and to miss the important factor of the inevitable relationship and progression, that there arises the attitude toward new forms in art which would belittle them as being a "fashion." Thwarted conservatism tends to evade the obvious omnipotence of growth by asserting that the new form will pass; will, in all probability, give place to some reaction which in its turn will re-instate the outcast old. This is a half-truth of critical judgment. Indeed if we look back over the whole history of art and literature we cannot fail to see that progress has worked along lines of continual action and reaction, a swinging of the pendulum, nay rather, a spiral which recoils upon itself but arrives at its point of starting with some slight movement upward which gives value to the excursion to the extreme. Such movement, such extreme, examined sectionally might be regarded as being so temporary as to warrant our dismissing it as a fashion ; examined in relation to the art which precedes it and the potential art to which it leads, examined even further as a wide sweep of the creative human mind gathering into the eternal stream of artistic purpose some element lying out at its farthest bound, and we begin to understand that the "fashions" of art are its method.

Untruth in art lies not in following the fashion of one's time but in attempting to pour the new wine of thought into the old bottles long outworn. Looking at the work of Shakespeare to-day we see that it was tremendously the product of his day, that it is in the fashion which it helped to create by its existence and its success. Not the "less Shakespeare he," for that, neither for the fact that his contemporaries regarded him as a dangerous innovator and

"upstart crow." He did not even realise probably that he was accepting the moulds of the dramatist's art which his time placed in his hands, nor that in some respects he was jeopardising the tradition which the academic critics of his day held to be essential to the production of great work. Great artists neither accept rules consciously nor break them consciously. Being, more intensely than their fellows, at once the reflection and the creators of their epoch, they invariably extend that paradox into their work by becoming primarily the makers and the breakers of the rules of art which apply in their time.

The comprehension, therefore, of any period of artistic thought and attainment necessitates our penetrating beyond the accidental fashions and modes of the environment of that period, and grasping those essential things which are the realities and fundamentals of art. These, when we have found them, must be relevant not only to the individual and the period, but to all individuals and all periods. They must account alike for our appreciation of and joy in the art of the Syrians and that of the present day Royal Academy, of the Orient and of the Occident, of the animal paintings of the Ming Dynasty and the work of the last "ism." It is safe to say that any theory of art which fails to be thus comprehensive is wrong somewhere ; while any doctrine which will yield criteria comprehending all will prove invaluable to our real appreciation of art.

The analysis of numerous art forms and the study of different periods and media, as well as an examination into the psychological bases of æsthetic appreciation, convinces one that much of what passes for appreciation of pictures or sculpture is a literary interest in the subject matter, entirely

dissociated from æsthetics, or at least allied to it only at its crudest. Beyond that we receive the thrill of the power over technique which accounts for so much of the enjoyment of cultured people, and finally we have the true æsthetic value which will prove the ultimate test.

That final test is the abstract art value.

By its power the Egyptian Sphinx, delicate Hindu carvings, the crude gods of Polynesia, the statues of a Michael Angelo, of a Rodin, and the works of the modernists alike become art—works of sculpture. The same principle applies to the graphic arts and to painting. Moreover, it is reiterated in all branches of art, where apart from any question of subject matter there is evidenced certain qualities of pattern, of rhythm, of the relationship of part to part and of part to whole which constitutes the evasive quality.

It was after finding my way to this conclusion—that art's basic value was its abstract significance—that I was introduced to the work in painting and sculpture of Lawrence Atkinson.

He has concentrated upon just those elements in art which to my mind give it lasting value. Working apart from the ordinary art-life of our time, and being free from the temptations which beset the average practising painter or sculptor, he has been able to follow his own star unhindered by the need of conforming to the fashions of the art which receives immediate recognition. Throughout years of experiment at home and abroad, and from a deep knowledge of the evolution of creative work, he found his interest centred more and more upon the non-representational elements in the arts. With this experimenting came a deeper understanding of the qualities inherent in the great classic works of all time, and a desire

to create works which would retain those elements in their purest form without regard to the mere literary and sentimental phases with which they have been overlaid during the last few hundred years. Thus he came at last to the love and practice of pure abstraction—simply building from his inner consciousness a form which embodied certain ideas or emotions in the lines and masses which satisfied his mind as being the incarnation of those ideas. In common with many artists in all media who have courageously· followed their inspiration without regard to its chances of finding a public, Atkinson has been to some extent rewarded for his faith in his impulse. His sculptures and drawings are receiving an amount of recognition even in England, where conservatism in the arts is the despair of all who are concerned with æsthetic progress ; whilst abroad, where interest is much more keen, he has achieved real success. In the International Exhibitions in Geneva and Milan his work created a deal of attention, receiving at the latter Exhibition the Grand Prix and Gold Medal.

My own introduction to it on any large scale was early in 1920. Before that I had seen occasional drawings in Exhibitions, and had been interested in the design for the cover of the 1918 edition "Wheels," an anthology of Modern Verse. At this period I was giving lectures upon Modern Art and through these I was brought into contact with Atkinson, recognising that his work constituted a practical illustration of the theories which I had found from a study of historical art, and of the philosophy and psychology which constitute a mental approach to æsthetics. Since that time I have had continual opportunity of studying his work, and of discussing with him his general aims as well as his specific

intentions in the various pieces which he has had on hand. Always I have found his work interesting me chiefly as successful exposition of the logical trend of art to the abstract which has for long been my contention. Recognising, however, how essential it is that if we are to have these new doors in art opened to us, there must be some initial attempt to clear away the lumber of ideas about the need of some sort of representation, I have aimed in this volume at presenting the case for the new art, using Lawrence Atkinson's work to illustrate the argument. The first section of the book is a synthetic statement of the business of all art and an essay at placing the newer tendencies in their relationship to the schools which have preceded them. The second section is an analysis of the art and æsthetics of Atkinson which will constitute an empirical approach to the subject. In this latter portion I have taken the opportunity of analysing not only his art generally and that philosophy of creation which governs it, but also have taken a few of the better-known works and subjected these also to a process of analysis. It has been throughout my purpose to create that mental atmosphere in which the work of this kind must be approached, and to pay tribute to one whose truth to his own idea of art's purpose has been of real assistance to the whole movement of subjective art.

The Approach of Philosophy.

T HE true appreciation of any phase of art—whether it be that of the safest of the traditionalists or the work of a modernist and experimentalist such as Atkinson,—depends upon our realising the basic function of all art and its place among the activities of man. This method is the road to catholicity. Understanding what art aims to achieve we can judge every school or work of art in the light of that aim, and we find that the most diverse and irreconcilable methods prove successful under the test. The grasping of such fundamentals leads necessarily to an examination of the metaphysics behind art, for only thus can we escape the deceptive surface values. What then is this activity of the human race which we have given the name of Art? What also is its relation to life itself? We are prone to hide behind vague generalities calling it the "creative impulse," "expression," and other titles which can bear a different meaning to every mind. It becomes desirable therefore to glance at the whole problem of philosophy and see where Art fits into the scheme of human thought and activity. It has been the crowning achievement of the human mind not only to accept sensations but to analyse consciously the sensations received, taking an objective view even of mind itself and its workings. Allied to this consciousness of himself in man is a realisation of the universe about him; equally thorough, analytical, critical, and energetic in its search for truth.

" LYRIC "
Sculpture

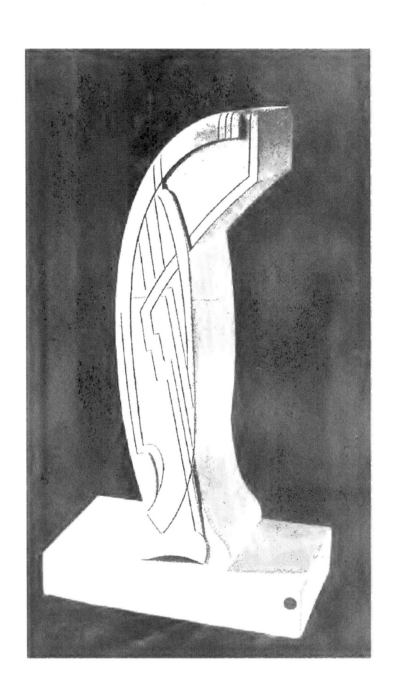

This dual power of inspection and introspection has set mankind the task of endeavouring to understand just what the universe is and what exactly is his place in it. Early in the performance of this task he was forced to realise that the solution of the problem depended upon the comprehension of two factors widely if not entirely diverse—mind and matter. With that knowledge came the deep cleavage, one group of thinkers going for their clue to truth to the world of matter, whilst another turned to the understanding of the human mind, asserting that only by fully grasping that instrument of knowledge could we attain truth. Extreme schools of thought went so far as to deny even the existence of the phenomena with which the other side were concerned, so that one arrives at the paradox on the one hand of such thought as Bishop Berkeley's assertion that the mind is the only reality; or on the other, that of the materialistic thinkers who would tell us that mind itself is so obviously part of chemical and material change as to be but one phase of material.

Broadly there arose four lines of approach to the problem. Science, philosophy, religion and art. Science, approaching the material universe through the senses, analysing, tabulating, and achieving its results from inductive reasoning ; philosophy establishing hypotheses concerning the universe and mind ; religion, presupposing a supernatural first Cause removed alike from the sensatory universe and the mind of man ; and finally, art, wherein the mind of man is moved by some internal or external force to the creation of phenomena anew in some new medium. These four diverse methods often coalesce, and the pursuit of one can seldom be consistently made without reference to the others. The purpose of all four activities is the achievement of some point of contact between man and the

universe. Religion which believes, philosophy which thinks, science which seeks, art which creates, each alike have purpose in the quest of the ultimate. Their success and the pleasure which we get from their pursuit comes from the recognition that at one point we have imposed meaning upon chaos, have said, " let there be light " and light has come. Joy comes to us from consciousness, especially when allied to that consciousness is some assurance of permanence and power.

In the " Conclusion " to the volume upon the Renaissance, Walter Pater has thrown light upon this doctrine in what has been not wisely called " the philosophy of sensation." In this essay, taking his stand upon the Heraclitic doctrine of the mutability of things, Pater continuing, points out that even the eye which sees and the mind which records these fleeting things are passing also with the eternal flux of matter. With the Greeks this factor of impermanence gave rise to the sad doctrine of the Epicureans : Eat, drink and be merry for to-morrow we die ; and to our moments of love of life so soon as the element of transcience is permitted to intrude comes the sadness, the fear. For we fear chaos and non-existence beyond all else. We fear the all-engulfing darkness which seems so closely to encircle these egos of ours ; our real melancholy,

" Dwells with beauty, beauty that must fade
And Joy whose hand is ever at her lips, bidding adieu."

But if we can find by faith, by thought, by experiment or by that re-iteration of the miracle of creation which we call art, that there is an underlying law and purpose in the universe, then the individual may take hope again that he too has some purpose.

In the ordinary moments of life this fear of annihilation is too far down in our subconsciousness to be recognised as

operating. When, however, we see, hear or feel something especially good to us we tend to feel also the wind of its passing wings. Thus it is the lover and the artist who are most likely to voice the fear common to us all. For these are they whose lives are likely to achieve that complete consciousness of phenomena of which Pater also speaks, where the recording mind is focussed upon some point of outward matter or of inward feeling which is itself for the moment intense. "To burn always with this hard gem-like flame, to maintain this ecstasy, is success in life," he says.

So it is that moved by the impulse to retain for himself, perhaps to pass on to others the joy of these moments of consciousness the artist creates in a new medium the outward thing or inward mood which he deems too precious to be permitted to go down in the wrack of things.

If he understands its nature enough to recreate its most essential elements there seems some assurance of permanence in a universe otherwise transient. And again if he thus can build the thing in his mind it presumes a power in the innermost part of man which is greater than the blind laws of nature. Something which existed at one point of time and space has by his will been created at another point of time and space ; something which his mind conceived as worthy has been added to the sensuous universe and communicated to others ; something which might have been thrown into existence by a chance coming together of chemical elements has been so understood by the mind that its governing factors and relationships can be recognised and re-made. It all means consciousness and power, the triumph of law over chaos, of mankind over nature, a link between the two elements of mind and matter.

To the artist, of course, this deeper implication is not present in his consciousness however much it may be acting beneath the surface. He only knows that he has what he may call an inspiration, conveyed to him either from his inner thought or from some chance happening in the sensatory world around him. He desires to express it, and having mastered the technical difficulties which might impede such expression he conveys by symbols the emotion or idea which has originally seemed worthy of such effort.

Deeper still in the field of æsthetics we find a repetition of this principle of the craving for assurance of existence, when we realise how great a part repetition plays in the creation of works of art. The repeated theme of a musical composition, the balance and repetition of line and mass in pictorial and plastic art and in architecture, the recognition of interdependence which governs colour harmony and juxtaposition, the rhythm or rhyme in poetry, the intrinsic sound structure of great prose and oratory, all postulate that certain things which exist in one time and space are linked intelligently with phenomena in other time and space by some essential orderliness. The body may have passed in the eternal mutation of things but the essence continues functioning and none other than that individual thing could have that exact effect. The artist will use a line at one point of his painting, will cause it to cease when its immediate purpose is served, then at some other part of his canvas will create it anew and our eye dwells with joy upon the triumph over the chaotic which the fundamental of pattern yields. This linkedness and unity, this all-potent interdependence in nature is the essence which the artist reveals. We realise at last that it is this element which gives us our joy in nature itself and that the process of art clarifies and makes

recognisable the pattern. Moreover it asserts the supremacy of the mind of the artist which can create essentials and can demonstrate the power of the human spirit over the chaos. Art is nature re-expressed in terms of the conscious mind.

This assurance of law and meaning inherent in the world of created things I believe to be the basic explanation of our joy in art, satisfying as it does that innate desire for certitude and continuity of existence, as on a lower plane this desire is satisfied by the expression of the instincts of hunger and sex. All love of power is this, and the love of power which the artist exhibits is one over the most threatening aspects of non-human phenomena.

In the case of representational and pictorial art this element is, of course, functioning. At its crudest it is represented by the power of the artist to save for a little time some scene, some pose, some combination of elements which he realises would in the course of the greatest natural law inevitably change. Something inherent in the thing as it is presented to his senses makes an appeal to him, and he re-expresses it in the terms of the medium at his command. Around the frieze of the Parthenon the fleeting momentary poses of horse and horseman were held for hundreds of generations in the sculptured stone. That, indeed, was one phase of man's triumph over time and matter. But greater than this was the innate quality of mind which caused him to differentiate between pose and pose, to create his lines and masses in the stone so that the essential and vital elements were held, and the confusing factors which doubtless existed in the original were eliminated. This is before all else the artist's task. Art is nature plus the discriminating mind of man. The work of art which is merely objective fails in its first purpose.

With the incoming of this subjective element into art, its meaning broadens, and broadens along just those lines of the assurance of power which I have indicated as being essential to our æsthetic pleasure. It is a remoulding of this sorry scheme of things nearer to the heart's desire, an elimination of undesirable elements, an emphasis of the qualities which please. Particularly those qualities which are essentially rhythmic and patterned have always found expression. The interest consciously lost and picked up again, varied within the greater unity, implied even in its periods of absence, always, whatever the factor happens to be in which the artist is interested, the expression yields pleasure in so far as we feel his power over his means of re-creating it.

So far as manner is concerned it is this feeling of conscious power which has sent us worshipping technique. In matter we have tended to rest content with an almost minimum achievement, or rather we have degenerated from the understanding of the need of rhythmic treatment which was characteristic of the earlier artists to an acceptation of lesser things in the mere representation of nature sentimentally seen. Always, however, there has been a tendency to revolt among the more live creative artists. It has expressed itself in many forms and many schools. Revolt has pressed forward to new formulae, or harked back to some period of the history of art when the quality of subjectivism has been manifest.

Born from the union of these two tendencies, that of seeking for the fundamentals of art in the creations of the past and of establishing new methods which shall prove potent for the future, has come the form of art expression which we call Abstraction. We hold that what intrigues the human mind and gives us pleasure in the works of the past, be they of whatever

DANCE MOVEMENT.

Water-colour

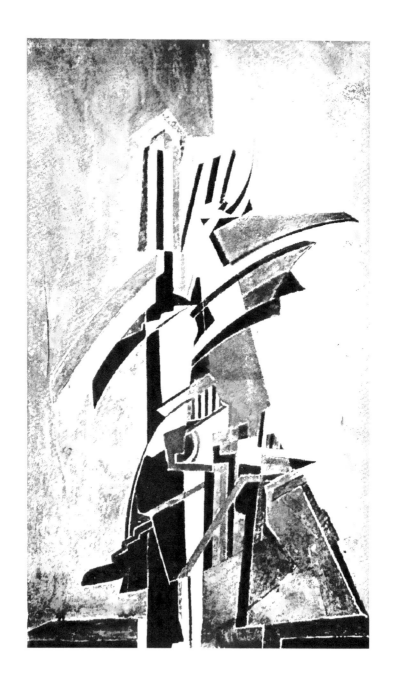

age, is not the literal interest of the subject, not even the symbolic interest which leads the mind through the sensuous impression to certain religious ideas, but that inherent quality of arrangement of line and mass which of itself gives satisfaction. That is, the element of pattern in its purest essence and unalloyed by the literal and other interests to which art has become subjected, has been recognised as a motive for creation. This composition value, harmony of line, mass, and colour are regarded as in themselves sufficient to create the æsthetic emotion, whilst such additions as come through the pictorial are held to detract as much from this pleasure as they can yield in return of other interests.

Moreover, it is argued that certain lines and masses have through generations of association come to have certain reactions upon our subconscious minds. We know for example how tranquilising is the effect of a series of horizontal lines, what movement can be conveyed by a waving or zig-zag line, what sense of menace can be given by weight at the top. These are the obvious cases which will be accepted by anyone. To the artist who has trained his mind and his susceptibilities to an appreciation of these facts in art production the primary and emotional-æsthetic appeal of his work will often be made by a definite usage of them. Even though the work be representational and traditional it becomes impossible to produce great work unless either consciously or subconsciously this factor is recognised. In the case of the art of Lawrence Atkinson it is given paramount importance. The appeal, the æsthetic, comes from the immediate significance which the lines, masses and colours have. With trained minds this process will probably be a conscious one ; they will recognise why a certain drawing, a certain piece of sculpture makes them feel a mood of exaltation,

of tragedy, of vitality or any other along the gamut of human
feeling. But the ultimate success of this art is that the same
feeling will be conveyed to minds incapable of analysing their
own emotions, because it depends for its success upon an appeal
to race experience and universal things. It becomes, indeed, art
almost removed from the accidents of personality or individual
experience. We know, for example, how fatal it is to much
work which is along ordinary pictorial lines that the mind of
many people is incapable of dissociating the picture from some
entirely irrelevant detail. Thus a view of the Alps wherein the
artist has been chiefly concerned with the wonderful balance of
the masses and interweaving of the lines with which Nature has
achieved that mysterious element of fitness which we call
Beauty, will serve often enough to recall the teatime
strawberries and cream at the hotel at the foot of the pass.
These associations are pleasant enough, but because of them the
real æsthesis with which they have nothing in common
becomes lost. The artist has some purpose greater than that
served by the picture postcard. It seems reasonable, therefore,
that we should evolve an art form which will present this pur-
pose in its purity, unalloyed by the thousand and one chance
associations of which the human intelligence is capable.

In the work of Atkinson a belief in the potency of the
appeal of form itself to the subconscious is a first article of
faith. He holds that art to be truly useful and democratic in
the best sense must base its appeal upon this hinterland of
consciousness where the accidentals of different nationalities,
experiences, cultures, religious beliefs, find reconciliation. At this
point the artificialities disappear in the face of the truly natural ;
men and women become Mankind. Moreover, he holds that
the artist also is most likely to fulfil his function by releasing

his mind from the obsession of the conscious and working at the dictates of these forces deep down within us all.　As he works there come the moments when he knows without further questioning that the form he is creating is one of satisfying beauty, that it strikes the chord of feeling somewhere deep within himself and may be trusted to achieve a similar effect on others. In the greatest sense of the word Atkinson is a mystic.　The material is to him a mere embodiment of forces beyond itself. Anything in life or art which arrests the human mind in its groping for the things behind phenomena is to him failing ; and the art which stops short at the material is a disservice.　So it is that his pictures take us to the very bases of our knowledge, to the things we feel because mankind has always felt them, because probably they are a definite point of contact between that incomprehensible inward thing we call mind, and this equally incommunicable outward thing we call matter.

The Approach of Psychology

THE inter-relationship between mind and matter lies, indeed, at the root of the problem of art as it does at the basis of philosophy. Arising probably out of that desire for self-realisation which I have asserted in the last chapter to be the motivation for so much of human effort, comes the attempt to bridge the gulf between the self and phenomena beyond self. When by some means a bridge is built between the two the individual experiences a joy—a joy which we but vaguely understand. Often it comes from some such artificial stimulation of sensation as is offered by narcotics ; the lover has it in its quintessence through mental and physical rapport with the beloved ; the saint achieves the same result through some moral or mystic contact with the universe or with the Power behind it ; the philosopher and the scientist attain it in the realm of intellect, the one approaching the problem from the standpoint of mind and finding a path through to matter, whilst the other analyses matter and co-ordinates it in terms of mind.

Then, too, there is the approach of the artists. They are the quickened senses of the race, the eyes and ears of mankind, the skilled hands creating phenomena anew. Through the senses they *feel*, as few of us feel, the contact with things, and because of the intensity of this feeling they must re-create, re-express.

Says James Stephens :
> " I shall die unless I do
> Find some mate to whisper to."

That second desire to bridge the gulf between the isolated self and the something behind self—the desire which is probably behind what has been called " the gregarious instinct "—is the secondary motive of the artistic enterprise. Based upon a deep-seated human need, it accounts for the method of art creation and the process which causes the artist first to achieve a contact between outward matter and his individual mind, then to recreate from his mind in terms of matter so as to link up with other minds beyond his own. The rhythm thus achieved of matter—mind—matter—mind is true to all forms of art, to whichever of the senses the artist happens to be making appeal.

In this process the artist is forced to realise that if he is going to succeed in passing on the original thrill which came from the stimulus of some outward phenomenon, he must recreate that phenomenon in some form clarified from the elements which militated against his fellows enjoying in the first instance the æsthetic emotion which came naturally to him. He must analyse in his own mind, winnowing the essentials from non-essentials and then expressing the essentials in symbols which his fellows can understand. The result should be a synthesis built of those factors which he deems fundamental and freed from obscuring accidents. Thus only can he hope to achieve the focus necessary to convey to others what to him has proved worthy and significant. All art partakes in this way of the nature of caricature, but the good artist is he who sees that his restraint precludes the sense of the ludicrous upon which pure caricature depends for its effect.

It is at the point of the choice of symbols that there comes a parting of the ways between the schools, the variety of choice appearing at first glance so great as to make this business of art seem almost anarchic. But investigation reveals two broad lines of creative method, depending respectively upon the emphasis of those constituents of mind and matter which we have seen to be inherent in these problems of æsthetics.

In the first method the artist represents the external surfaces of nature as nearly as his medium permits. In the second he presents symbols which signify the ideas or emotions existing or created in his own mind. It is not possible completely to differentiate the two so as to achieve a water-tight compartment either of the representational or the presentational method. Even the camera-picture is probably subjected to some amount of choice and manipulation on the part of the photographer, and if the photography is of a high order at all this subjective element will be certain to have entered to a pronounced degree. On the other hand, even the most purely abstract art depends consciously or subconsciously upon some reminiscence or association with the external world of form.

In spite of this encroachment, however, it is permissible to see the methods of art under these two headings. The first, the method of illusion, makes it appeal to the senses by a pretence of being that which it is not ; the other, depending rather upon the potency of its symbols, speaks more directly from mind to mind.

It was in 1818 that Coleridge, with the insight of the philosopher said : " The real illusion consists not in the mind's

SCULPTURE

Alabaster

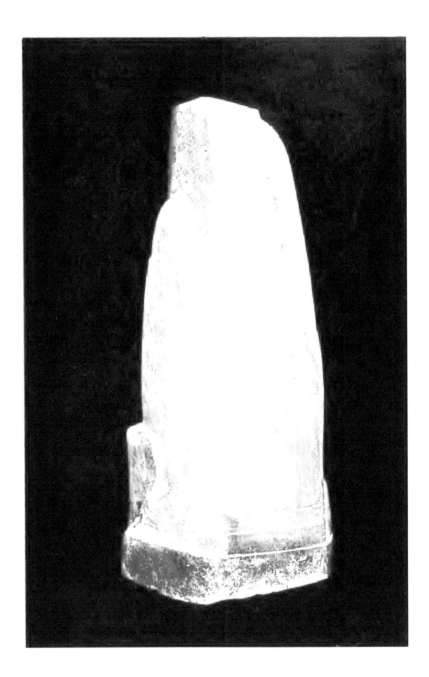

judging it to be a forest but in its remission of the judgment that it is *not* a forest."

That, indeed, is the fundamental, and the artist who can create his symbols so as to hypnotise the mind to the acceptance of whatever idea or emotion he desires to convey, is the successful artist.

Everything, it will be realised therefore, depends upon the symbols chosen, and a mere repetition of surface appearances of nature is the crudest and most materialistic method of work. The symbol essentially is a short cut between mind and mind. Civilisation has been the triumphant mastery of this form of communication ; particularly in conveying the deepest emotions, the most significant aspects of our relationship with each other and with the universe, have we tended to utilise symbology.

Art, at its best the servant of these deeper feelings, has perfected the use of symbols. The great periods of religious art, for example, have left us countless examples of the works of masters wherein is manifested the use of a symbolism derived from the church or ritualistic customs of the time. The art of the East has become almost entirely an art of symbols which could be depended upon to call up in the mind of the beholder certain ideas, to engender certain moods.

This use of symbol has degenerated at periods into a certain clumsy reversal of its own methods, whereby something or some quality, in itself simple, is conveyed by a complex symbol. Of this kind is the false symbolism of the Neo-Platonists, of a Maeterlinck, or of such painting as represents a single human quality in the guise of a person portrayed in such a way that out of the complexity of their actions we

are able to deduce the quality for which they stand. One mentions this in passing because, newly freed from the late-Victorian artists, we tend to think of this degenerate symbolism when we consider symbolism at all. It is necessary to realise that in the hands of a great artist the symbol must be simple, the significance must be greater than the signifier. It must, indeed, partake of the clarifying down to essentials which we have seen to be part of the process of art.

It is necessary to remember that some form of symbology as a bridge between mind and mind has always been the method of art, and to realise that the kind of symbol chosen by the representational school is rather a departure from the true tradition of art than otherwise. The tendency to revolt against this clumsy symbolism has been the basis of all the subjective schools. Each in its turn has been seeking some more effective language which would convey by purer means than that of the repetition of natural objects, the elements within nature which the artist deemed significant or beautiful.

One further analysis of this subject of symbolism is necessary if we are to find criteria which will guide us in understanding works of art. This is the difference between symbols which arise external to art but are utilised by the artist for his purpose, and the others which may be said to be pure art. The cross and the circle will suffice to illustrate : without penetrating into the very early history of the cross as a symbol it is sufficient that its association with the Christian story and subsequent theology has given it in Western eyes certain significance of sacrifice and salvation not inherent in its actual form. The symbol thus is external and literary, depending on a certain set of facts historically and upon a certain culture for its acceptance. To the

Hottentot, for example, the cross does not mean these things because to him and to his experience neither the Gospel story nor the Christian teaching exist. The circle, on the other hand, has come into its place as a symbol because of certain inherent qualities. It conveys by its intrinsic line the idea of continuity in time and space which is part of the universal stock in trade of ideas. When Vaughan says :

> " I saw eternity the other night,
> Like a great ring of never ending light "

he is stating in words what the artist drawing the circle has always consciously or subconsciously expressed. The circle is pure art symbol ; the cross is applied symbology.

In dealing with abstract art this difference in the kinds of symbolism is important. Based upon the same needs of linking mind with mind through a medium of matter, and using the same methods as are common to all art of all time to satisfy this need, abstract art breaks fresh ground in its dependence upon the use of symbols having inherent significance. It becomes in this way more self-contained (more infinite, Hegel would tell us) than the art which depends upon factors not primarily æsthetic.

In an earlier chapter it was shown that the artist working on these lines so far trusted his art to speak for itself as to rely on his achievement of sub-conscious associations rather than upon the conscious. Because the symbols are those which came from the sub-consciousness they will be attuned to the sub-consciousness of others and so art's purpose will be achieved.

One other factor which accompanies the choice or acceptance of such symbols is their translucence of the pure

idea. The representational art of surfaces, even the more
subjective art of symbolism and presentation, are prone to
arrest the mind at the contact of surface—to make the appear-
ance or the symbol an end in itself. If this happens, the
enslaved senses hold back the mind also, imprisoning it in the
material instead of leading it beyond to the deeper thing for
which· the merely material stands. The line, mass or form
which does not rely upon such conscious or cultural association
for its effect is the more likely to be freed from this danger.
Its appeal is straight to the underlying spirit or mind of the
beholder, and the reaction of the instinct is inevitable. Even
with the abstract work of art, however, and the piece which
sets out to depend upon what I have called pure symbols,
there is some danger of the deepest intention of art failing
by the creation of some sensuous surface charm and an opacity
between the outward work and its inward meaning. For the
artist who is really intent to convey, the supreme task must
be to keep the channel clear. The probabilities of failure
are lessened if we will remember that a symbol should never
be an end in itself, and always should be the shortest path
to some ultimate. When the symbol is the crude one of
representation there is every chance that the mind will pierce
no further than to the thing represented, and will miss entirely
the really deep language of art. In the case also of the per-
fection of technical achievement which has become, in the
eyes of certain critics, the supreme motivation for art, there
is every chance that the mind will rest satisfied with the
external and will penetrate no further. It becomes largely a
question of whether the artistic centre of gravity is in the
thing itself, or in some ideal and abstract thought-concept to
which the thing has given a clue.

Abstract art claims to be the inevitable symbol of this deeper world. The fact that it lacks superficial meaning is a guarantee that the mind cannot be arrested on the frontiers of expression. The fact that it grows rather from the sub-consciousness and from the instincts of the artist than from the cultural and intellectual leads us to assume that its appeal will be straight to the non-volitional in others. Based upon pure symbol it pursues its path between mind and mind with the minimum of retarding matter. Abstract art is a channel to the infinite, not a cul-de-sac of the senses.

The Problem of Technique.

IT has proved one of the stumbling blocks to a wide-spread appreciation of the more modern forms of art that many of its exponents have affected a revolt against the "high finish" which had become an essential of academic art. The needs of illusion have long demanded that the medium should be disguised. Canvas, paint and stone were subjected to a pretence that the surfaces which they represented were really composed of the depicted material. The love of the medium for its own sake which caused Michael Angelo to link up his sculptured masterpieces with their origin by leaving a fragment of the stone untooled, was curbed by the tradition of illusion. The truth about illusion was sacrificed to the illusion of truth.

One of the earliest phases of the insurgent movement was the search for reality. Often, and especially in the early days, this search led to the commonplaces which we have given the title of realism, establishing, for example, in the English theatre the so-called Manchester School of dramatists, and in English art groups and individual artists whose subject was the truthful rather than the beautiful.

A logical reaction against the sentimentality which had long held art in thrall, this emancipation in subject matter was accompanied by the incoming of truth in manner. The painter *painted* ; his brushmarks were left on the canvas as the visible confession of his joy in his work. Sculpture was left unmodelled at those parts where the artist's theme made no demands for treatment. Under the new ethical-æsthetic impulse the artists

" MARCHERS

Water-color

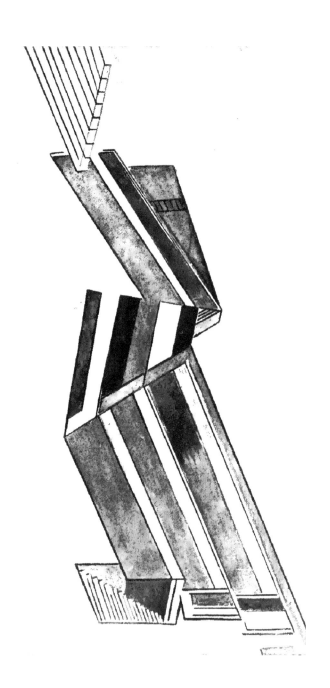

opened the doors of their studios, as it were, and the humanism of the activity of creation was added to our joy in art.

With this change of manner certain critics have become too enamoured, making of it the main difference between the new schools and the old. Under their guidance we have tended to hail as "new" much work which is governed as to subject and art philosophy by the motivation of the old, sharing with the new only this broadening conception of the love of medium. Let it be granted that this is a healthy development so far as it goes, but insistence upon any one point of art is the building of barriers to progress, and this cult of the technique of disillusion, can only be emphasised so long as the relationship of technical skill to the whole business of art is understood.

To regard technical prowess, whether it be in the new manner or in the old, as the fundamental factor in art is to confuse the means with the end : to encompass the human emotions and intelligence which should be freed by a work of art, within the confines of mere skill and workmanship.

But while the critic-advocates of medium and method were busy leading the ordinary public into the workshops and studios, the artists themselves, led by the dictates of artistic necessity, were pressing these new technical methods to the point of paradox. They were frankly reaching the point where technique had entirely passed beyond being an end in itself and a sign of their first joy in emancipation. Nor were they in any danger of returning to those forms of art where technique was a highly skilled means of denying its own existence. They felt, indeed, that this whole business of technical skill was overdone, and realised that it tended to an undue exaltation of one phase of the artist's work—an unimportant phase having little to do with art's fundamental purpose.

In this knowledge the moderns tend to react from the prac-
tice of any such supremely skilled technique as has held sway
for many years in art. Thus we witness the phenomena of the
" bad drawing " on the walls of picture galleries, and that dis-
regard for the accepted excellencies of "putting on paint"
practised by artists whose earlier prowess in their work leaves
their capacity in these directions beyond dispute. All is part of
that process for clarifying art down to its basic meaning and
purpose, and the desire that the finished work shall become a
pathway to something beyond itself. Thus it is that the
moderns have invented a technique of their own, not to be
confused with the old technical efforts at illusion.

The fundamental law of the new work is that the workmanship
is governed by the thing to be expressed. Its excursion into the
realm of " art for art's sake " has endowed it with a freedom in
the choice of material and of method which is now consecrated
to the end of expression. As an extreme example one thinks
of the building up of a picture with the aid of tin, newspapers,
match-boxes and wire which has been regarded as the wildest
eccentricity of such men as Picasso or Archipenko. Yet it must
be realised that when, as in these instances, the artist was con-
cerned with a very definite form of surface realism and the re-
lationship of surfaces it was legitimate to utilise actual objects
and materials as a medium, and as intelligent as it would have
been to represent it exactly in paint.

Much of the opposition to the new art forms comes from a
kind of trades-unionism among practising artists and art teachers,
who deprecate the work on the ground of what they call its
" facility." That it may not need prolonged (and expensive)
practice such as is demanded by representational art and " high
finish " technique is not in the least a reason for adverse criticism
when we remember that art should be a means and not an end,

and that technique is a language. It would be of enormous value to the human race could we achieve a means of expressing æsthetic ideas without years of costly apprenticeship during which the inspiration dulls. Unfortunately even the newer forms of art are not so attuned to the millenium. The artist freed from other people's traditions tends to work out his inspiration throughout the whole of his art career in the terms of a technique demanded by its inherent qualities. By constant experiment he will find those materials and methods most exactly suited to the expression of his particular message. He will use just those things which he believes will prove the line of least resistance to his ideas or in the conveyance of his æsthetic impulse. That, to the modern, is the basis of technique.

We have grown to an appreciation of the confession of method, because actually by such confession the mind is able to dismiss method. The cult, for example, of the woodblock which has revived as a recent phase of art activity, is a manifestation of this acceptance of medium. The obvious wood effect says to us quite clearly : this is the most direct means of conveying to you the thing I wish my art to express ; in wood it found its most clarified form.

Art definitely abstract is given a wide choice of media and methods. The test must always be whether the individual work *feels* right in such a medium ; whether a certain effect succeeds in itself—and not whether an artist's use of line or colour is better or worse than that of his predecessors in art. If a weak use of brush, chisel or pencil causes an artist to fail in " getting over " the effect which he has striven to convey we may rightly criticise. But always we must be sure we are measuring his achievement by the standard of his own aims and not by that of some tradition or aim extraneous to himself and his work.

The Approach of History

O NE further method of approaching the question of any phase of art, and one likely to assist in our understanding, valuation and appreciation, is to see it in its place in the whole development of art. In the case of the new work this study of the varying movements of painting and plastic art which have preceded it will be of particular value in showing it as a step in a definite series, the logical sequence from a number of preceding movements. Two lines of error inevitably arise from the kind of loose thinking which has hitherto impeded the progress of the newer movements : on the one hand we have the idea that the new art is a form of æsthetic anarchy, isolated by the arbitrary whim of its exponents from legitimate art ; on the other you have the confusion of all the modernist movements and the belief that they are all governed by one idea, vaguely called " Cubism." If these prejudices were confined to that person whom we choose to designate " the man in the street," it would not be a question of great concern, but actually the confusion is existant among many people really interested in the fine arts.

There can be no real understanding of any phase of art without some comprehension of its relativity to all art, and its causal environment, as well as its apprehension as something absolute in itself.

Investigation proves that any form of art, even the most pronouncedly individualistic at first sight, is the direct result, either by continuity or reaction, of the work which has gone before.

Art is the freest expression of the human mind and it is impossible to think of any " Thus far and no farther " to its activities.

It remains therefore to trace briefly the course of painting and sculpture through what are called the modern movements, in order to obtain an appreciation of such work as this of Lawrence Atkinson, and to see how far he has departed from his predecessors and contemporaries, and wherein he is allied to them.

From the time of the decline of the Byzantine school about the middle of the thirteenth century the art of Western Europe followed a trend to imitation, natural representation and likeness to the object which eventually swamped all other reasons for producing a work of art, all other methods of presenting an object artistically. By the end of the nineteenth century this naturalism had reached a point of perfection which (the human mind being kinetic and not static) was bound to give rise to reaction in some form. Portraiture and landscape painting had reached something near perfection, the nude had exhausted the mathematics of its variations, whilst in England we had the rise of that school of portrayers of emotional episode and sentimental incidents. A little shocked by the everlasting nudes of the more frankly sexual French we inclined here to divert art to this portraiture of persons, landscapes or incidents, whilst the backwash of the Pre-Raphaelite movement yielded occasional crude symbolism inspired by Neo-Platonic idealism. The perfection of technical skill which went to the creation of these works entitled them to their claim as works of art. Then, too, the prolonged study of the classic and other schools caused our artists to pay attention to " composition " which meant usually that beneath the literary, sentimental or realistic exterior was the element which we now recognise in its purity as abstract form and from the inherence of which I believe came the basic æsthetic joy.

Often they builded better than they knew. Just as Giotto for
the best of reasons led art astray in the mid-thirteenth century,
believing that he was fulfilling its destiny, so at the commence-
ment of the twentieth the people whom we call the Impression-
ists led art back from the representational in an endeavour to go
one step further along lines of that convention. As with most
schools working under the stress of a real philosophy of art they
achieved a distinction in both the conception of what should be
created and in their technical method of doing it. Their first
difference arose from the realisation of the factor of the part
which the senses played in this business of art. There was an
instinctive recognition of the facts of scientific optics in their
understanding of the elements of focus and of the reactions of
light upon an object, whilst in their technical method this same
recognition was reiterated. In essence they said : we will not
paint the object *as it is*, but we will paint the impression which
it makes upon the eye. Regarding light and colour of light,
therefore, as the factor of supreme importance and the element
of unity between an object and its environment, or between the
parts of an object or landscape, they concentrated their technique
upon an adequate presentation of this element which would con-
vey to other eyes what had impressed theirs. For this presenta-
tion of pure truth in a certain aspect they realised that it was
not possible to continue with the false assumption that the eye
can focus upon near and far objects at the same instant and they
reduced their pictures to the point of time which, accepted
theoretically in pictorial and plastic art, had become extended by
the tendency of the artists to take the eye from part to part of
their canvas giving everything in turn its own known value
rather than its visual worth in relationship to other things. It
was light and the movement of light from object to object, from
surface to surface which they depicted, and the actual forms of

" MEMORIAL "
Sculpture for a Cenotaph

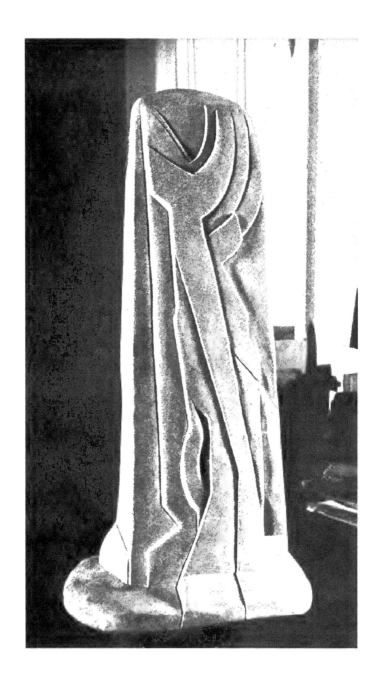

objects as the artist knew them to be were a matter of far lesser concern. Especially valuable, too was their contribution to the actual colour phenomena of shadows : their willingness to accept what the eye conveyed, revealing the tremendous colour value of the planes which were denied direct light.

Technically they again used a fact of optics for the conveyance of impressions. They used as far as possible pure colour placed in such juxtaposition that it mixed in course of optical transit. Thus the mixing and toning of colours took place not as an actual fact on the palette or canvas but at the point of sight itself. The result was a gain in that the pictures were endowed with vibrant light and colour which was fresh and vivid, but a loss of outline and pure form. In the hands of the greatest exponents such as Monet or Pissarro the essentials of form were conveyed clothed in a glory of light ; in the later stages the lesser men tended to feel that the absence of definite line permitted carelessness of form, and to imagine that exaggerated shadow-colour constituted a sufficiency of æsthetic interest.

Viewed from the point of art-progress, the value of the Impressionist Movement was that it broke away from the representation of the object as it was in the world of fact, and depicted it as it was presented to the senses. It was a step towards subjectivism ; it was a recognition of the part which the senses of the artist played in this passage between mind and matter.

The instinctive experimentalism of the artist invariably results in a scientific school of his followers if the experiments succeed. Arising out of the Impressionist technique came a scientific use of the method of applying pigment in its purest state to the canvas in the work of the Pointillists and others of

similar schools, whilst the important main stream of tendency toward subjectivism led to the experiments of the Post-Impressionists. Here the artists realising that expert knowledge of colour reactions and form and colour values could be a matter of pure art, conceived their pictures of these elements and created them of this æsthetic material, going to the external world of fact only for the slightest hint of subject. The further step towards subjectivity practically passed the limits where the artist depended for his effect upon nature's accidental arrangements of form or transient effects of light and shadow. Art was a language between mind and mind. At this period, however, the forms were still natural forms, presented with the artist's knowledge of the play of light and colour upon them. Representation was still accepted as the basis of the subject matter of art, however far the artist had proceeded along the line which recognised presentation as the basis of æsthetics.

So far it will be seen that the new tendencies were chiefly the outcome of enquiry and understanding of colour phenomena, and that form had tended to be neglected in the search for expression in the terms of light and colour. It was at this point that there came into the new movements one of those reactions which recurrently correct extreme tendencies. Cezanne turned from the study of the transitory reactions of light from the surfaces of matter and brought back the sense of form to which the Impressionists were inclined to pay too little attention. It was, however, no mere reaction to the conditions of representation which had held before the coming of Impressionism ; rather was it an application of the same principles to the architectural, the material, the form side of objects. It was this interest which sent Cezanne and many others among modern artists to still life for their subject matter. Being interested in form for its own sake

and for the sake of the definite stimulus which it gave to the senses, they imposed upon nature a grouping which brought out the lines and forms in which they were interested. Angles, the balance of mass against mass, the relationship of lines with each other, of part with part and of part with whole, the effect of one line or mass upon another, the modification by environment —all, indeed, which concerned or expressed the construction— these things were the art-content of the second line of advance into the realms of subjective art. In the course of its development this, too, tended to work to an extreme, producing form which was not a clarification of the objective form after it had been tried in the crucible of the artist's mind ; producing half-likenesses to nature which lost the details of the form of the individual thing and failed to compensate by adequate revelation of the structural significance of the kind.

The two tendencies which we have traced in Impressionism and the school of Cezanne, the one towards a subjectivity of colour and the other towards an intensification of form had their logical sequels respectively in the theories of the Futurists and the Cubists.

The former of these movements was the outcome of a recognition of a fallacy of Impressionism, a contradiction between its practice and its philosophy reconciled by taking one more step into subjectivity.

On the one hand the Impressionists emphasised the need of concentrating upon the purely subjective, whilst on the other they would only deal with that one point of time which we have seen to be an integral part of their practice. The logic which was by this time governing the progress of the art movements argued that if subjectivism were to be the basis of art the

limitations of time and space were quite arbitrary and as such might be discarded at the will of the artist. If, they said, we wish to convey the impression which a street scene left on a mind, we may attain a greater degree of truth by recognising the fact that such a memory is of disconnected fragments, a face here, a building there, the play of light, the successful advertisement. The resultant impression may be chaotic ; it is the duty of the artist to re-express it in line and form and colour so as to impose a pleasing unity whilst retaining just those elements which in fact were of interest to him to the elimination of other less significant elements. So was born Simultanism or Futurism as it was optimistically called by its exponents, who headed by Marinetti, the versatile Italian artist and thinker, felt that art took a new lease of life with this definite acceptance of the human mind as the fusing point of a work of art. In its abandonment of the phenomena comprised within the actual range of vision at any given moment of time as being the only legitimate subject matter for art, the Futurists had indeed made a fairly important break with traditional art of the modern world. It enabled movement to be recorded, and in other ways brought pictorial art nearer to the other forms of art which had not accepted this limitation. The work was, of necessity intensely individualistic, recording phenomena in transit through the mind of the artist. Its subject interest apart, its æsthetic value depended chiefly upon the actual arrangement of lines and forms, the balance of masses, the relationship of part with part, and beyond this with the accepted conventions of tone and colour values. Technically it demanded much more of the artist than the old form of representational art. Both in selection and presentation more depended upon his intellect and less upon the natural appearance and juxtaposition. The appearance in England in the Post-Impressionist Exhibition of 1910 of pictures in the Futurist

manner created the nine days wonder which steps in art progress will cause. The success of such men as Boccioni and in England of Nevinson in the new method, however, gave it a definite standing among the lovers of art who were prepared to admit that there was any possibility of movement whatever.

This whole phase of art progress was, therefore, the logical sequence of the tenets which the practice of the Impressionists and Post-Impressionists presupposed. Alongside of it there came a development of the newer appreciation of form which we have already noticed as existing.

The search for the architectural values of objects which marked many of the new men, gave rise to a revolt against any softening of the contours and blurring of surfaces, combined with a definite emphasis of the masses of which an object was constructed. Out of this principle came the school which gained the title of " Cubist." The origin of the name seems to be obscure, but the practice of the workers in the manner depending so much upon the reduction of an object and its surfaces to approximate cubic masses, and the elimination of curved lines in the belief that herein lay a gain in strength and a freedom from sentimentality, gave some justification to the title. It is not my purpose at this point to discuss the logic of this theory ; one simply records it as part of the progress of art from the representation of nature to the subjective art of our time. In the course of the development of Cubism, the movement towards subjectivism received fresh impetus when the artists experimented with arbitrary arrangements of the masses and forms which they obtained by their analysis of objects. The most advanced work of this school became so far removed from objective phenomena as to be practically abstract. The value of the school came from its

realisation of the need of expressing form in its purest state ; the failure came from the fallacy of the assumption that the straight line alone expressed strength, and the limitation which claims structure as sufficient for the needs of art.

Alongside these movements, partly accepting, partly re-acting from them were certain other phases of art which have had an important bearing on the evolution of art form and thought.

There was for example that whole movement towards simplicity and away from the over-sophistication of art which gave us Gauguin and the Fauviste movement with Matisse at its head. Gauguin was a pure reaction back to nature. He saw civilisation as a disease and turned in revolt from the over intellectualised art of Paris ; he accepted much that the Impressionists and their followers could give him in the matter of colour and had a leaning towards the expression of rhythm in form which allies him with the moderns. His chief in-terest to us now lies in the barbaric colour and subject matter.

Another painter whose practice had an enormous influence on the whole development of art was Matisse. He also represents in some sort a reaction from the over-subtlety and he also owes something to either wing of the move-ment forward. He quite frankly aimed at expressing objects with a maximum of significance but a minimum of means. To this end he used linear design filling in the spaces obtained by almost flat washes of colour. Again the artist has escaped the three dimensional method of illusion, this time for the presentational method of reducing his subject to decoration and pattern in two dimensions. It will be seen therefore

" EARTHBOUND "

Sculpture in Stone

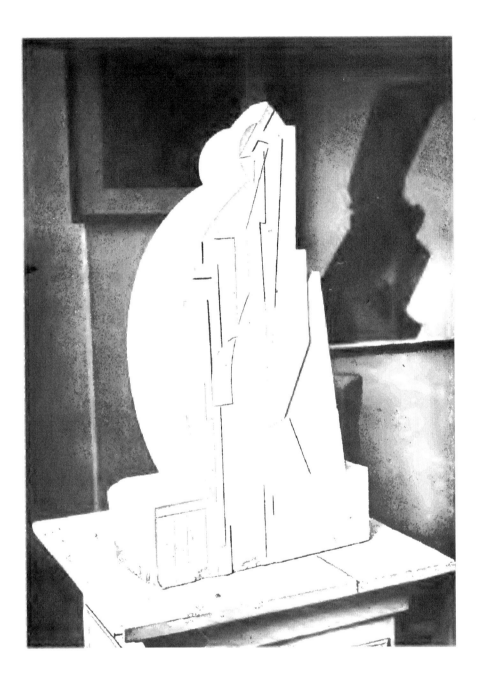

that he was really aiming at an expression entirely opposed to that which in due course inspired the Cubists, whilst at the same time both schools are essentially subjective and presentational in their methods. At a later stage the work of Matisse and his followers was remarkable for their treatment of the rhythm of line. They were depending on line as surely as the Impressionists depended on colour, or the Cubists on mass, and naturally with the development of the idea this element tended to be over-emphasized. For the sake of linear rhythm or to emphasize some relationship of line to line, the artists distorted their models, calling upon their own heads the fury of the critics who accused them of wilful unnaturalness for the sake of mere novelty or sensation. It is this school of thought which aims at minimising means of expression which is at present in another phase operating under the comprehensive name of Expressionism in Central Europe. Whereas the French Fauviste group, however, were primarily concerned with something definitely æsthetic, with problems of form and line, the present German group are most interested in some definite quality of their subject which may have no especial æsthetic significance whatever. The difference arises largely from the basic differentiation between Latin and Teutonic culture, the former being more certainly concerned with form and manner, whilst the latter is devoted to subject matter.

These diverse movements it will be realised were united at one point : they aimed at expressing in a medium of art something subjective. While all art was a process of matter being assimilated into the artist's mind, and re-created in matter so as the more easily to find entry into other minds, the tendency of all the modern movements was to

the elimination of the first element, or at. least to the emphasis of the second as being of greatest importance.

Abstraction in art is a frank acceptance of the implications of this tendency. It owes to the movements which have preceded it a great deal as to technique, as to the importance and value of colour, form, mass, rhythm of line. Its use of these experiments is to step back from objective nature and realising that the elements of art are capable of creating emotions, feelings, and that quickening of the human spirit which we call æsthesis, the Abstractionist creates from the pure matter of art, pictures and sculpture to this end.

PART II.

The New Art in Practice

THE ART OF LAWRENCE ATKINSON

Four pieces of
Sculpture

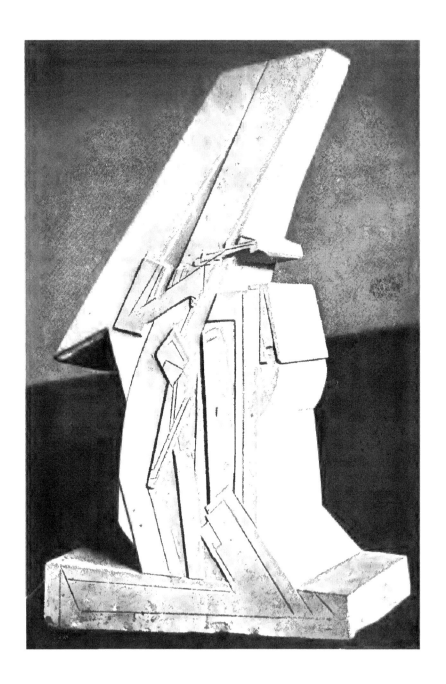

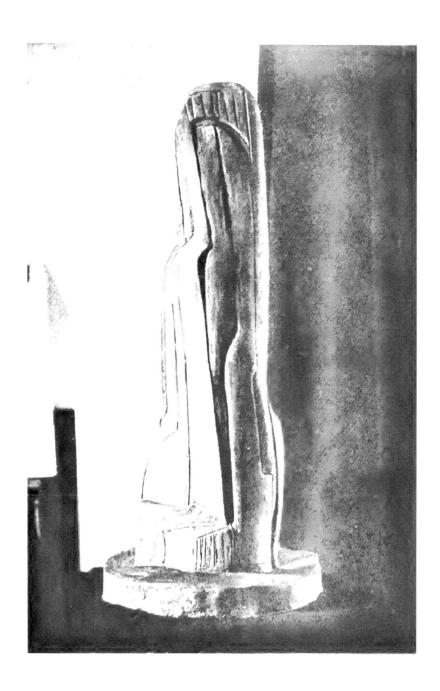

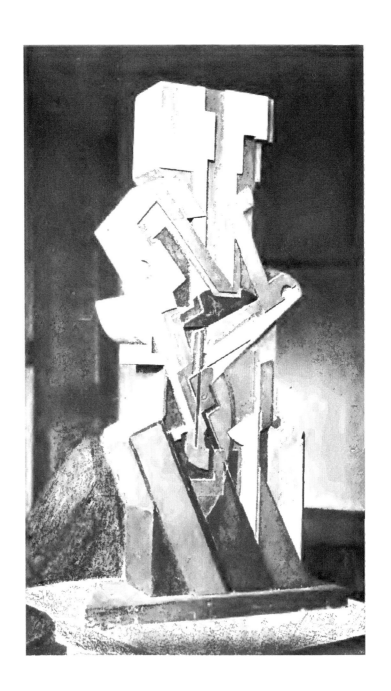

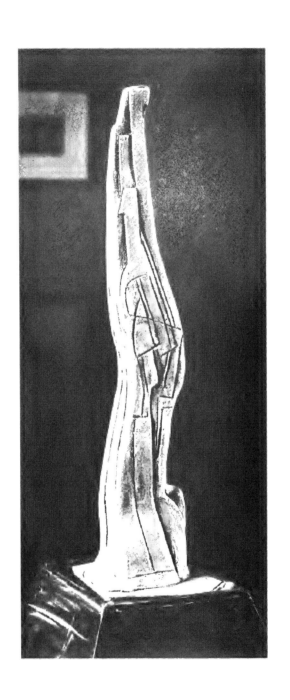

NOTE :

The use of the term " Abstract " in respect to this art has been criticised. Lawrence Atkinson himself prefers the word "Synthetic," feeling that the other might connote an abstract rendering of concrete appearances. My use of the term implies an art expressing abstract thought. Thus the matter is Abstract ; the manner Synthetic.

Lawrence Atkinson

His Work and Place.

IT is frequently charged against those of us who are advocates of modernism in art, that, whilst it is possible to advance a perfectly logical and convincing case on its behalf, whilst it is provable that the new forms are basically sound, acquaintance with the actual productions convinces one to the contrary. Certainly if this were true it would nullify any theorising which might be advanced. Unless as an actual fact, fine art achieves its purpose of conveying some vision of truth and beauty, all the enthusiasm of theorists is unavailing; the test of art is not in its satisfaction of a theory but in its satisfaction of basic æsthetic demands.

It is generally admitted even by the most adverse critics that the practice of the new schools here in England received justification in one respect and at one period. As an expression of the war, of the mechanism of life which war meant, the new art proved a terrible efficiency. Depending chiefly upon the methods which we now call Expressionistic this war art in the hand of the younger group justified itself as an expression of truth. One of the most skilful exponents, Wadsworth, found for it a place even after the war in the presentation of a phase of life equally hideous, ugly and soulless, and his use of semi-abstraction to convey the

horrors of industrial England had social value in the success of its sincerity. In the eyes of some critics, however, all this constitutes as much a criticism as a testimony. Thus it is claimed against the new forms that they are capable of expressing truth—especially unpleasant truth—but not beauty. This has often constituted the criticism of the schools, for however pronounced may be our admiration of the expression of truth it is certain that we shall always ask of the fine arts that other element of beauty both of subject matter and manner. It is the existence of this quality, expressed in the most advanced technique, which constitutes the first appeal of the work of Lawrence Atkinson. He is now thoroughly and frankly an abstractionist. He has passed through phases of discipleship to many other schools, and one can find among his works, pieces inspired by the practice of Impressionists, Fauvistes, Cubists, Simultanists ; one can find, too, the evidences and traces of these theories combined in some of his pieces or influencing the later abstractionist work. But his work remains fundamentally beautiful and appealing, dealing only occasionally with unlovely facts, expressing almost invariably the deeply pleasing things and emotions. It is this element of charm which attracts first to his work.

The second is that it contains that mysterious factor which is characteristic of all great art—the element of wonder. Always one feels that it has been this approach to the universe which has produced the great work of the past, and the reverence accompanying it has added to pictures and sculpture their basic religious character. The element is non-scientific. It accepts facts beyond science ; it accepts science as a road leading from the known to the unknown—a road being gradually explored. It is reverential and spiritual : a little out of keeping with the cynical scepticism of our times.

"INTERIOR."

Pen and Ink Drawing

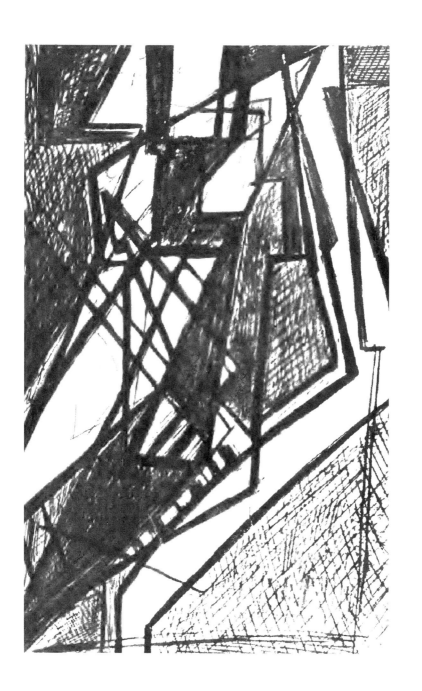

These allied elements of beauty and the sense of wonder are factors of so much importance in the work of Atkinson, that one is tempted to think of them as constituting his chief claim to our interest. Analysis shows, however, so much else of interest, so many links with modern tendencies that the whole body of his work may rightly be chosen to illustrate what we mean by modernism in art. It enables one to demonstrate the beliefs of the potentialities of the new forms. Atkinson has not confined himself to any rigid theory. He has experimented in matter and manner ; he has followed the individual demands of each subject wheresoever they led and so created successful work in both painting and sculpture. Recently he has pressed his practice into the region of applied arts, designing rooms on the abstractionist principle. Consciously accepting an intrinsically mystical basis for his work, he is a thinker and philosopher whose conceptions of the universe are expressed in paint and stone. He has too that belief in the potency of the sub-conscious which is so essential a part of the thought of our time.

So great a part does this philosophy of the sub-conscious play in his work that it becomes necessary to examine its bearings upon the question of form as he sees it.

Atkinson holds that the tendencies in art, and more especially perhaps in the modern forms, have been towards an over-sophistication and a dependence upon the intellect which has militated against the acceptance of much work by the mass of the people, however much it may have been received and admired by the understanding few. He is convinced, moreover that there is in the greater pictures and sculpture some universal appeal. This appeal, quite apart from any business of subject-matter is the direct emotional one which arises from the

intrinsic form and colour structure of the picture and is only emphasised by further consideration of the technical prowess, the representational or literary appeal of it. To an artist striving to delve to the really basic things it is this element of pure beauty which constitutes the most important factor, and it is this same element in nature which holds the human mind so often to a state of intense emotion.

Wherein then lies the secret of this power of line, mass and colour to affect the mind? Always the psychologists reveal it as depending in some way, either direct or indirect, upon association, and it is a pursuing of this theory of association to its source which has played so important a part in the theory of subconsciousness which lies behind Atkinson's work.

He believes that generations of race knowledge have led us to give a certain definite value and meaning to various forms. This repeated association of certain lines and colours with certain experiences becomes at last part of the common heritage of the race so that these lines in themselves and apart from any actual symbolic or representational value which they may possess, will inevitably excite these reactions. The whole process becomes so certain as to be instinctive rather than what we call "reasonable" (although the difference between the two things is probably one of time-reaction rather than any intrinsic difference of kind). One sees this happening crudely in the obvious instances, such as the tranquilising influence of the horizontal line, the sense of security of the pyramidal structure, the eternal circle. These and the score of other examples which spring to mind reveal the kind of basic association which we cannot doubt exists. It becomes equally evident when we examine colour and its effect upon

us. So sure are we now of this sub-conscious influence of colour that it is almost universally used in such practical matters as interior decoration and in therapeutics. We are growing to realise that the instinctive reaction occasioned by the proverbial " red rag to a bull " has parallels in human psychology resulting from the various colours. The acceptance of these crude instances of suggestion in both line and colour opens up the probability that there exist the more subtle ones, penetrating the inmost recesses of being and registering upon the sub-conscious that which the cruder consciousness fails to mark.

To an artist of Atkinson's philosophic trend, with his desire that his work should speak clearly to his fellows, this analysis of form and colour and the realisation of its instinctive associations prompted the idea of its fullest possible use as a language. Influenced to some extent by the teachings and theories of Goethe and of his disciple Rudolf Steiner, Atkinson held a firm belief in the importance of the sub-conscious and in the power of both colour and form to speak directly to it. Fully to appreciate his work it is necessary to understand this tendency of his mind to concern itself with forces operating in regions far removed into the Hinterland of human mentality. Not that it is necessary that one should be able to trace the connection between one of his pictures or sculptures and this point of psychic reaction, for if his theory and practice are successful the effect will operate without a superficial understanding of its method. This, indeed, is true of all forms of art ; it appeals or it does not appeal and there seems no possibility of stating definitely why. Nor is it only to the critic and the psychologist who are able to some extent to analyse the effect of the art upon themselves that the appeal is made. Their enjoyment may be the greater because it is a more reasoned one, but often it is less than

that of the unsophisticated person because their power of
analysis brings into their minds qualities alien to their enjoy-
ment. So it is with this abstract art of Lawrence Atkinson.
It succeeds or fails with a person not because that person can
fully comprehend the nature of the emotions and ideas it
arouses, but by some almost mysterious harmony or lack of
harmony. In the biggest sense of the term all art thus
becomes religious—a binding together of the mind of the
artist and his audience through a mutual recognition of truth
or beauty. In this sense the art of Atkinson is religious art.
He believes that the universe is bound together, is functioning
and fulfilling itself by and through the operation of laws
of interrelation and mutuality working through the medium
of the material. Seeing the whole art of the Western world
expressing the philosophical tendency of the Western World
in the glorification of the material with a minimum of
understanding of the forces which gave this material signifi-
cance, Atkinson's essentially non-materialistic outlook caused
his mind to revolt against the current art and art formulas.
To him the material was a veil of the more important forces
behind it ; to him things and persons in themselves were
less significant than the giant powers which brought them
into being or operated on their existence when they were
established. Gravity was more fitly a subject for the artist
than the apple. He wanted to make his comment upon
something deeper than the sensuous appearance of things and
persons, and in his fear lest that external should interfere
with the universal which was his theme, he rejected the
image and boldly attempted to create the new forms which
should reveal without hindrance his psychic ideas. To our
minds long debauched in the sheer materialism of the West
this dependence upon something non-material is almost

incomprehensible. But it is essentially religious and takes us back to the periods of art when the symbol spoke to men's minds of the forces which they felt to be functioning.

One further fact about the mental make-up of Lawrence Atkinson which has had an appreciable effect upon his art is his life-long work as a musician. Acting upon a knowledge of this fact it has frequently been asserted by critics that his painting and sculpture is " music in form," or as the title of one article by an eminent authority hailed it " Music in Stone." This, with the frequent quotation (and misquotation) of the sentence of Walter Pater " All art constantly aspires towards the condition of music " has conveyed an impression at once false and true. There can be no doubt that a life largely devoted to the study and interpretation of music has moulded Atkinson's mind to an appreciation of the fact that enjoyment and kinæsthesis may come from a non-representational method of speaking through the senses to the emotions as well as by the further method of what has been called " pure music," that is, music which depends for its beauty upon its own interrelationship as an intellectual work of art. Understood thus as an influence upon a mind already pre-occupied with the non-material the part which music plays in this art will be admitted. But alongside this is the fact that Lawrence Atkinson has deliberately chosen to express himself in the graphic and plastic arts because he realises the danger of the sensuous appeal of music as a power which holds the mind as he would say " to earth." He has always aimed at a medium and a method which would prove transparent, revealing clearly the non-materiality. He knew that music in some of its forms could be as sensuously beautiful and meaningless as a painter's palette or as intellectually self-sufficient as a problem in mathematics. But the art which he had conceived was to be a channel between

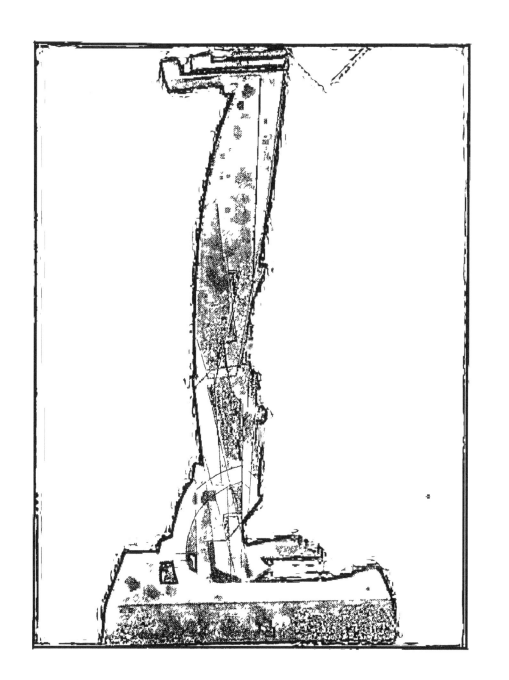

only inasmuch as their results came to him and convinced him of their value. His art study was conducted in the great galleries all over Europe, and by passing contact with the minds of contemporary artists. All the time he was thus travelling, bringing the art of the past and the present to the test of his own individual vision, he was practising expression in every medium and within the theories of every school which presented itself to his notice and seemed to offer what he sought. No partisanship for or against some "master" interfered with his search for a medium; he was able to serve the mistress, Art, to whom he had dedicated himself, with an unsullied service. His art as it evolved through these years was purely his own, individual and free from cramped conformity to any school, clique or theory.

One other result which these years of travel and varied life in many cities had upon the development of Atkinson was that he achieved a wide culture. It has often been said of artists, and not without truth, that their minds have the compass of their studios. To anyone who has led the studio life of any one of the art cities of Europe the danger of this narrowness will be known. It is difficult, indeed, to realise that there exists anything outside the discussions of this man's painting, that man's etching and the personal gossip of the coteries. As a consequence art tends to reflect a narrowness of view, a lack of grasp of other issues. In place of this, Atkinson's method of pursuing his studies put him into contact with the broad questions of life and the intellectual problems in all the important countries of Europe. He became cultured in the wide sense which takes in the study of politics, religion, and all phases of humanism as well as those problems of æsthetics which tend to monopolise the usual art education. His reading in philosophy, in general literature, in political and sociological writings, his daily contact with men and women of

different nations and races, and his own experiments not only in painting but in poetry and other arts were fitting him for the task which he had set before himself. To Express, he realised, you must have a mind stored with the facts of the world of your time. Only thus will come the real understanding of that time and an expression of something of real value. A study of the lives of all the artists who have attained lasting reputation reveals this factor of the cultivation of a wide view, of a concern for the life about them, and the consecration of their art to the purpose of expression.

Out of these factors of the intellectual and social world of his own day, and moulded by his own particular cast of thought and the influences peculiar to his own work as musician, has evolved the art of Lawrence Atkinson. In such circumstances it could not but be individual, it could not fail to have something to say. It has grown straight from this individualised outlook upon the world and upon art. Removed from the temptation to conform or even to abandon conformity for any reason outside the æsthetic one of its own inward necessity, this art stands to our generation as the expression of a free mind in our midst. Its freedom makes it important, for art must be free.

CHAPTER II.

The Paintings : Early Work.

IT will be realised from what has already been said of the influences operating upon Lawrence Atkinson, both those internal ones which arise from his own personal cast of mind and those which come from without in the shape of the artistic and philosophical activities of our time, that his work in any direction is unlikely to be either static or formal. It cannot be stereotyped.

Two dangers beset the artist departing from the path of traditional art ; on the one hand he may find some formula which, although it is his own, exercises tyranny over him, until his work becomes a dead parody of his own once vital inspiration ; on the other he may be still under the thraldom of the art against which he has revolted, and this very fact may express itself in wilder and wilder efforts at revolt. Obsession by theory either in a positive or in a negative way spells the death of art. Theory is an accidental of art, the province of pedants and on-lookers. Let it be granted that there are times when the artist himself becomes the onlooker, considering his work objectively, but so soon as the creative impulse comes to him his expression of it will seldom have any conscious dealings with technique as an end in itself. Each subject will thus have its own inevitable technical expression, whatever unity appears arising from the compelling factor of the artist's personality.

With Atkinson there has been a definite and traceable evolution of his practice, governed by the gradual development of his own mind and the increasing inwardness of his theories.

Beyond this there has been the variety of method dictated by the necessity of each subject or theme. Often, too, there have been works which were in themselves rather experimental; and, whilst these have a very definite value and interest to the student either of Atkinson's work or of art movements generally, they will not be likely to stand against the pieces which come into being at the dictates of that strange inner necessity for creation known to all artists.

It were well, perhaps, to deal briefly with the evolution of artistic purpose which has led Atkinson from his earlier method of semi-representation to his later one of pure subjectivism. Even at the commencement of his career as a painter he had no interest in the mere reproduction of a figure, a landscape or an object. His first things show an intense sense of pattern and decoration. Many of them are landscape studies, and a glance reveals two elements striving for mastery as the chief motive of his work. The first is the joy of colour, the second that relationship of part to part and of part to whole which we call rhythm.

The love of vivid and vital colour was probably an influence from the Impressionists, whose revolt against the "art-shades" bequeathed by the eighteen-nineties had the support of all who were trying to rescue art from æstheticism. It was unlikely that a mind so ready to accept vital ideas as Atkinson's was, would withstand an influence making for forcefulness. It was, however, this same desire for immediacy of utterance which kept him from the special technique of the advanced Impressionists and from such experiments as Pointillism. His method, therefore, at this early period was much nearer that of Gauguin, a statement of his subject in terms of bold colour patches. Often he would emphasize the decorative value of these

by definite, heavy outlines, seeing his subject as a mosaic of beautiful colour and rhythmic form.

It was, however, to be the other element in this work which eventually became the leading motive in his art. He found that the structural values in an object interested him more than the merely decorative ones, and in consequence his pictorial work tended to be concerned more and more with the dual æsthetic interests which are inherent in structure—the first of which is the relationship of part to part, and the second that use of the facts of surface to emphasize the forces which go to the making of surface, the series of dynamics and counter-dynamics which rightly understood reveal the structural truth about an object.

This phase represents the second period of Atkinson's pictorial painting. One thinks of it as structural rather than decorative, although, as has been indicated, the element of structure was a very pronounced one even at the earlier time when decoration was primary. Psychologically the movement is a shifting of appeal, from the senses to the intellect. It is Bosanquet in his " Introduction to Hegel's Aesthetic " who says :

" Nevertheless the mind which only sees colour—sense or sense-perception—is different from the mind which sees beauty, the self-conscious spirit. The latter includes the former, but the former does not include the latter. To the one the element of colour is the ultimate fact ; to the other it is an element in a thing of beauty. This relationship prevails throughout between the world of sense and the world above sense. The ' things not seen,' philosophically speaking, are no world of existences or of intelligence co-ordinate with and severed from this present world. They are a value,

"an import, a significance, super-added to the phenomenal
world, which may thus be said, though with some risk of
misunderstanding, to be degraded to a symbol."

The movement of Lawrence Atkinson's æsthetic interest
from the sense-perception of beauty to the intellectual conception
of beauty accounts for much of the difference between his
earlier pictures and those of the second and, indeed, of all later
periods. In Hegel's sense of the term his work became sym-
bolic. That is, he became interested that the mind should not
be arrested by the surface beauty, but should be led by the
sensuous image to something more fundamental. The opacity
of surface charm gave place to the transparency of symbolistic
painting.

May I at this point define just what we mean by
Symbolism ? By a curious paradox born of our Western minds,
symbolism has become perverted in art, so that although it has
the essential characteristic of linking the outward and material
with the inward and spiritual, there has somehow happened
a change of direction causing the interest to flow not from the
symbol to its significance but reversely so that the mind is led
to the symbol itself as the ultimate fact. One sees this in Greek
mythology. As it degenerated the Gods became increasingly
tangible, their humanism belittling their divinity, their ap-
pearances holding them to earth. The Greek love of sensuous
beauty was fatal to the psychic import. With the Latinisation
of this culture the tyranny of surfaces and the material became
complete. Christian philosophy and Christian art at first stood
consistently for the transcendental values, being at its inception
Eastern and mystic. It was eventually beaten by the materialism
of the civilisation against which it was hurled. In art the
coming of Giotto and the end of the Byzantine work (which

" LIMELIGHT "

Water-colour

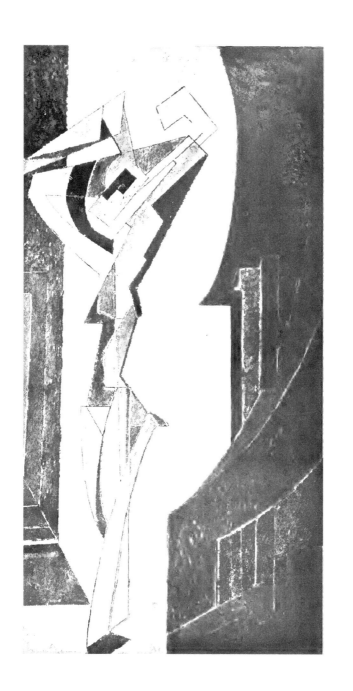

still retained the true element of symbolism) was the triumph of the materialistic world. With the passing of the Italian Primitives the victory was complete. No longer was the Madonna the Mystic Spouse of God ; she was some beautiful woman whose face and figure were a byword in some North-Italian town palpitating with sensuous life. Even the great semi-mystic Gothic art went down eventually before the splendid temptation of the Latin culture. The life of the senses, and at the Renaissance, of the senses restrained and intensified by the legacy of classicism, held our minds definitely to earth. Art became a spiritual cul-de-sac ; the symbols led nowhere.

There have been efforts to throw off this thraldom of the material. Blake, both in his literature and in his art, found a door in the wall. A thinker here, a writer there, a painter elsewhere have found egress into the wider air ; but on the whole Western art has stayed in its blind alley, crossing the road now and again from so-called " idealism " to so-called " realism," from " freedom " to " convention," and so adding a little variety to its existence. Always its feet have been well on the earth and its aspirations well within the reach of the world of matter.

Worst of all from the viewpoint of our need to get this problem of symbolism into correct perspective, there have been schools of artists who, under Neo-Platonic influence have repeated the materialising of the spiritual which we noted as the result of classic mythological thought. The loose terminology of our time has given the name of symbolic to any painting which erects a concrete image and gives it an abstract title, until such work as that of the late G. F. Watts or Walter Crane has grown to be regarded as symbolic, whilst the Pre-Raphaelites in their harking back

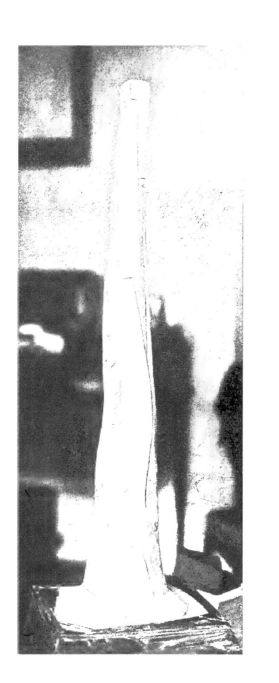

which his picture presented. Thus the cross, which to a realistic artist would be a gibbet with certain historical-literary associations, and to the ordinary symbolist the emblem of Christian religion, would be to him interesting as the symbol of a force thwarted but continuing in spite of this interference with its direction. It is something more than an accident that these three interpretations are all true, revealing the associations which the form has to the human mind, but showing themselves upon examination to be closely interrelated and mutually interpretative. Atkinson's symbols cling closely to the associations which line and form in themselves suggest apart altogether from literary or historical recollection. The object which inspires his drawings tends to analyse itself in his mind into these significant and revealing forms.

A further tendency which came into the work of what one might call the second period was partly an influence of Futurism, in that it accepted the Futurist tenet that the single point of time was an arbitrary restriction, having been accepted by the necessities of representational art but possessing of itself no fundamental æsthetic value. Atkinson's practice, however, differed largely from that which we have associated with the Futurists proper, in that his unity centred itself upon one object, and the time element was allowed to intrude only because movement was so much an essential to the object in question that presentation of it demanded the suggestion of its progress through space and time. In this respect Atkinson's work along these lines is less subjective than that of the school of the Futurists. They presented parts of an object or of many objects brought together from different points of time and space and gathered

into a pictorial composition because they had achieved an
unity in the mind of the artist ; he presented an object having
an unity in itself but having as an important element in its
nature this movement from point to point of space over a
period of time. Concerning himself with this movement in
itself he would depict it with lines which in their relationship
to each other and to a static environment suggested progress
to our minds.

One thinks for example of his aeroplane study " The Sky
Pilot." Such a subject could only be presented in represent-
ational art as a study in arrested movement—a method which
misses the basic essential of the theme. Treated in semi-abstrac-
tion by Atkinson, and expressed by a repetition of his forms in
cubic perspective, the picture conveyed a sense of actual
flight through the air. The design of the picture has the
feeling of mechanism, throbbing down a channel of night-
blue with blackness closing in on either hand. One would
like to ask the talented Editress of " Wheels " why this
significant blue was changed to meaningless red when the
design was used as a cover for the 1918 volume of the
anthology.

The thought of this expressive space-shape which helps
to give vitality to the study of the rushing 'plane leads one
to the other element necessary to the understanding of
Atkinson's drawings and paintings. He concerns himself with
the actual vitalising of space at the dictates of the relation-
ship of the various parts of his drawing which this space
separates. The method is a convention ; the reason for its
adoption is a psychological truth.

Atkinson realises that an object does not exist to itself
alone, but that it is affected by its environment and in turn

LOW RELIEF

Stone, with frame
of green wood

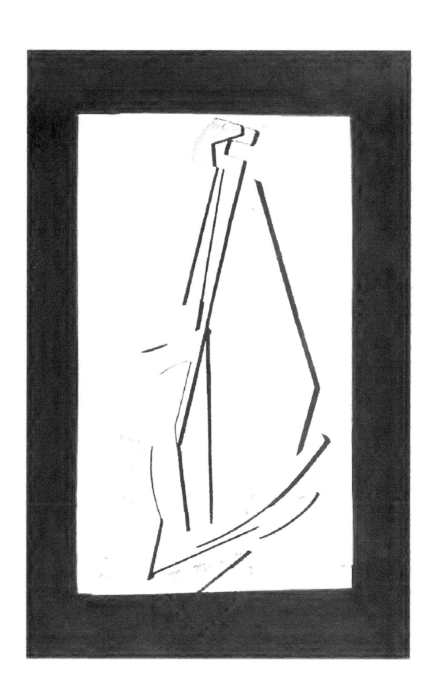

reacts towards it. One sees how this works in that other form of intensification—stage art. An actor standing at one part of the stage alone will focus attention ; at the need of the drama he turns toward a door and, without a word being spoken, our attention follows the direction ; the door opens and the actual visual focus shifts rapidly backwards and forwards between the open door and the man, the right gesture in that direction will carry our minds expectantly *from* him, and with the appearance of the new comer the space between them becomes alive with the flux and reflux of our interest. Dissociated entirely from the literary associations of the drama, the actual line and mass has this quality of expressive vitality, and no intelligent stage producer now omits to make careful study of the dramatic value of such expression. The movement of the eye and mind between closely interrelated points or parts of objects renders the space between them a gulf bridged, and it is part of Atkinson's art method to indicate with line and colour this linking. His space therefore becomes vitalized ; lines do not cease where the actual objects cease to have bodily existence but are carried across to other lines to which they have relation. Environment is thus given emotional as well as a structural value. This element of what he has called " spatial accordancy " is one which is of profound importance in his work.

It will thus be seen that this second period of his work was marked by a removal of the interest from the external decorative values to a consideration of symbolic form, an introduction of new elements permitted by the growing subjectivity of the work and a study of the emotional value of an object both as conveyed by its structure and as affecting its surroundings. He tended during this period to abandon

the passion for colour which had marked his earlier work. The use of too pronounced colour would tend to hold the mind too much to the sensuous beauty of the work of art as an end in itself, and so would defeat the artist's purpose of leading the mind through the work to the interests behind which had inspired it. His colour therefore became restrained and transparent, often a mere wash. Pen, pencil or brush was used to suggest these subjective-emotional interests which objects inspire in him, and the colour value added lightly, so that the expression was enhanced whilst the temptation to the merely sensuous was avoided.

There were, of course, varying degrees of success in his achievement as there must be in the work of any artist, and particularly in that of men daring enough to experiment. During this second period his work suffered occasionally from the fault which spoils so much of the output of the Cubists, Futurists and other modern schools ; it tends to over-sophistication and to too great a reliance upon its intellectual quality. In the most experimental stage in the work of almost any artist there will usually be a period when his own concentration upon art will lead him to assume that his fellows and those who see his pictures are thinking with his mind. It was the recognition of this error, and of its limiting effect upon his language as a painter, alongside of his growing conception of the bases of art, which led Lawrence Atkinson to the third period—that of Pure Abstraction.

The Paintings : The Abstract Work.

IF we ever believed in it at all we have now outgrown the curious cult of "art for art's sake." It becomes difficult to understand nowadays exactly what the phrase ever meant, save that it seems to have hall-marked the æsthete who could feel that the benefits of art were part of his exclusive inheritance however much it kept itself to itself. The art which affects limitations and is avowedly for a coterie, is art rendered sterile by its snobbery. Art is a language. It has a function to perform of conveying beauty or truth from the sensitive mind of the artist to the less sensitive minds of his fellow creatures. The problem which confronts the artist is the conveyance of his own vision without degrading it, so that his fellows shall be lifted up to the point of contact with the universe which has inspired him, shall see as he has seen, hear as he has heard, vibrate with his thrill, and receive through his work a like power of understanding.

To this end he clarifies and tries to render simple, always watching that the elements he eliminates are non-essential, and that his conception is not deformed at birth. The art of the Cubists, the Vorticists, the Futurists and other advanced schools had at last reached a point where the amount of conscious intellectualism demanded in producing a picture resulted in an almost equal amount for its adequate understanding. The recognition of this limitation was one reason why with Atkinson the influence of these schools was a transient phase. The other was that these schools are primarily interested in surfaces and appearances, whilst Atkinson has always tended to see through

these to the deeper things behind them of which they were the result. It was, however, along the line of the choice of effective symbol that he really arrived at his Pure Abstraction in art.

The things which he wished to express concerning objects and his method of achieving his purpose led him to the realisation that the original object which prompted the expression was often not at all essential to it. A group of figures, for example, suggests to him a study for " Grief." The people themselves realistically treated as a representational artist would do it, would add confusing elements to the expression of that basic emotion ; a reduction to essential poses and masses leaves a half-likeness which is distracting. The true *motif* of the subject lies in the pure arrangement of lines which ages of association and something deep in the subconsciousness of the grief-stricken leads them to assume. It is this arrangement which has attracted the artist and suggested the subject by speaking straight to his subconsciousness. If he is to convey it to others, therefore, it will be best to reduce all to this pure arrangement of line and mass. It becomes a step in logic to enquire what factor it is in this arrangement which so surely expresses the emotion, and if it is possible to find that factor, to treat it as a symbol, a word in your language of art. The use of such a symbol produces its inevitable reaction. Thus the whole process is one which takes place primarily in the realm of the sub-consciousness ; it is emotional and instinctive. As soon as we drag it into the light of analytical reason it evades us, shrivels, and leaves us with our bare facts void of meaning. These things which have become part of the universal heritage have sunken too deeply in to be easily analysed in the intellectual and conscious part of us. It is the belief of Atkinson that the purpose of the artist is best served by emptying himself of his own egoism, and escaping for the time the direction of his intelligence, remaining passively

waiting for the forms and lines which will satisfy his own sub-conscious groping. This, then, is his method of work in the third stage which his art has now reached. The emotion or idea may or may not be prompted by outward, external phenomena ; he concentrates himself to its expression in lines which will satisfy his instinct, seeking these lines beyond conscious intellectualism. Thus he hopes to achieve a universal appeal since he is depend-ing upon the phase of humanity common to us all, and the symbols which are potent by universal usage and a heritage of race association.

The success of the appeal of an art of this kind depends somewhat upon the preparedness of others to achieve a similar receptivity and a like unsophistication. If we approach it with our theories of art, with minds stocked with intellectual cross-references in æsthetics, its appeal is no more likely to be potent than is that of simple faith to the professors of dialectics and theology. That is not to say that its appeal ultimately cannot be analysed, but analysis and intellectualism do not con-stitute the atmosphere in which its power operates.

If Lawrence Atkinson is right in his faith in this art beyond intellect—and many of his pieces are so direct in their appeal that one can hardly gainsay his rightness—he has opened new doors in art and human expression. Such an art will get us back to the fundamentals of all art, giving our emotions a lan-guage of line, mass, and colour ; and the objects about us will acquire a symbolic value and prove an emotional stimulus, lead-ing the imagination through the prose of their being to the poetry of their meaning and creation.

The exposition of this doctrine of dependence upon the sub-conscious has already been made in the writings of Kandinsky, the one other artist of European reputation who has worked in this

way. Kandinsky's own practice depends much more upon
colour than that of Atkinson, and less upon form. Its appeal,
therefore, is much more sensuous, and is in danger of becoming
superficial. The contrast of the work of the two men brings us
up against the problem of facility which is so often urged against
modern schools of art, for it is urged against the work of Kandinsky
even more than against that of Atkinson that it appears to con-
tain no elements which could not be mastered by the uncultured
mind. This criticism usually coming from quarters where a
difficult technique has been exalted to a place only this side
idolatry is open to two objections. The first of these is that the
ordinary standards of ease or difficulty cannot be applied to any
work which has elements of genius or inspiration. The fact that
certain of the greatest musicians showed a power of the tech-
nique of their craft during their childhood surpassing that of the
ordinary person after years of stubborn practice does not degrade
the art which they served. Artists presenting works in the new
manner, in common with all artists of whatever school of thought,
will have varying experiences as to the ease with which a work
is born. At one time the whole idea and its working out will
form easily, at another the idea will but gradually clear itself of
the confusion of things about it, but the intrinsic value of a
work of art lies in its conception and power of stimulus and not
in the chance difficulties of the craft in which it is expressed.
The importance now attached to technique and craftsman-
ship is a reflection of the influence of the production of art for
the artists. Judgment of art should be based upon the end not
upon the means. Our approach to a work of art should be :
what does it say ? how does it move me ? Our concern with
the craftsmanship should only be as to whether the artist has suc-
ceeded in expressing the message which he intended. It is only at
the point furthest removed from real æsthetics that we probe

" VITAL "
Study for Sculpture

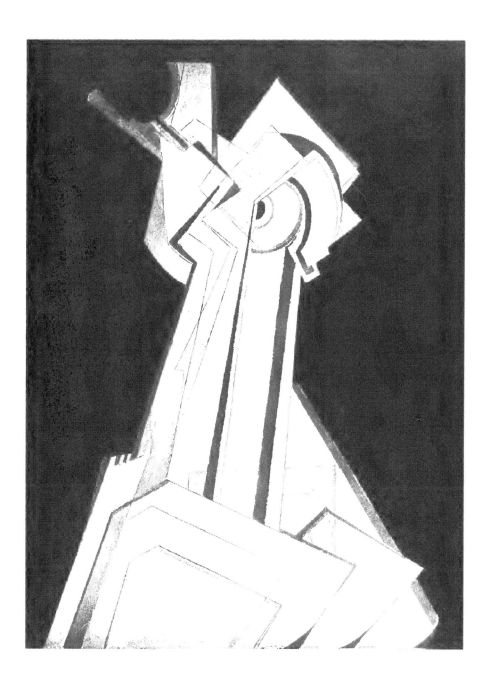

into the questions of how exactly the artists obtain the effect on the canvas, whether they paint " thin" or " thick," what palettes they use, and finally whether they produced a work with the maximum of physical and mental exhaustion or not. We do not rate Keats' " La Belle Dame sans Merci " at the bottom of our poetic literature because its metre, rhymes and language are obviously easily arrived at, given Keats' genius ; nor do we insist on knowing that he practised his craft strenuously for many years before he published the results.

The second objection to this criticism that "anybody could do it " is a pious wish that they could. We want art to be a universal language, and the trade of "artist" to achieve self-annihilation because everybody can use and understand its symbols. Then our lives will be art, and the adult human race will put away childish things which we now call works of art. This making of art production a close preserve of a few specially-trained, specially-cultured individuals is a typical outcome of our civilisation of competitive economics. In the same way the assumption that supreme difficulty alone gives value is the out-come of our ethics of competitive economics. The truth is that art will only really succeed when it is universally produced and universally understood, and that if any artist or group of artists can open the doors of human self-expression and human consciousness by the invention of a form of art which makes toward or achieves this universality, a new era will have dawned.

In the case of what is vaguely called modernism in art we are still far from any such ideal. Granting that the artists using abstract or semi-representational expressionism do not pay the slavish service to technique which has taken the place of genius in current art production, they are still having the enormous difficulties of technical pioneers. Moreover they have

given themselves the even more difficult task (and it may be added, more important one) of having something to express. The new art abandoning this comparatively easy conquest is forced back upon the real business of art—that of expressing something other than the manipulator's power over his craft.

In this third period of Lawrence Atkinson's painting, therefore, we find him freed entirely from the bonds of representation, and advanced beyond the theories of Cubism, Vorticism, and Futurism in his desire to express in a technique of pure form the invisible forces which govern the activities and dictate the structure of things. His precursors, such artists as Picasso, had been concerned with the rendering of surface facts and the comment of the artist upon them. Atkinson, however, commencing where these men stopped, pressed the enquiry into phenomena which art constitutes, one step further, and sought to reveal the psychic and material machinery of life which were themselves the cause of these surfaces. He concerned himself with the dynamics of power, growth and progress, in an endeavour to bridge the visible with the invisible forces behind it.

With so great a philosophic content to his work it must be realised that only by a process of extreme simplification and economy of means in its presentation can the artist hope to succeed in that universalising of appeal which has consistently been Lawrence Atkinson's ideal.

Pure line and pure form have to convey the message which has given him the impulse to create. Æsthetic joy arises from our recognition of the fitness of the forms to achieve this end, and from our dramatic interest in the activities of the lines and masses as such. It is the painter's art exalted to apotheosis, and by its divinity enlightening the baser world of material facts and evolution.

FIGURE STUDY
Painting on wood panel

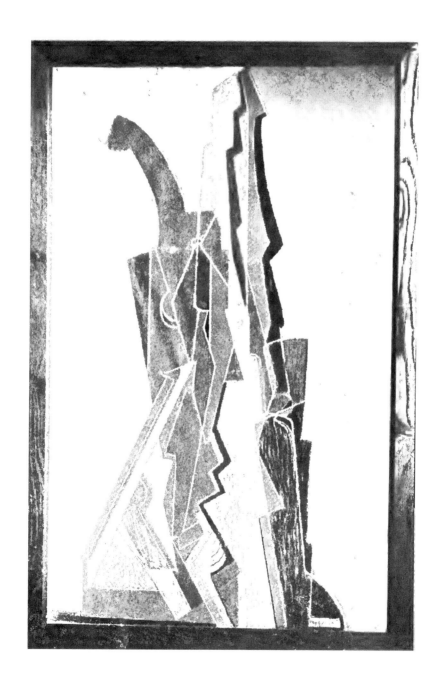

The Sculpture

HE courage to depend upon the inspir-
ation, or (if one prefers a less dangerous
word) upon the sub-conscious, should
result in an artist finding his real métier.
In the case of Lawrence Atkinson the
line of development was, as we have
seen, one which led away from colour
and on to form, and it was when
he had been concerned almost entirely
with form for some time that he realised
the trend of his art and commenced experimenting seriously with
sculpture as a medium. For an artist of his theories it was an
application of the acid test. Colour we know to have a certain
emotional value and power of causing reaction. It has nearness,
intimacy and a sensuous beauty not easily dissociated by the
charmed mind from the transcendental values to which the best
art aspires. Sculpture, on the other hand, making no compromise
with facile appeal, stands a little aloof. It accepts limitations so
that its intention be clarified. Eliminating the sensuous and
so passing the more easily to the ideal, it stands removed from
the life of the senses even at its most realistic and life-like.
It is this fact, probably, which accounts for its neglect, and
for the consistency with which art critics pass it over and
devote their attention to the pictorial and graphic arts. But
this very quality of non-sensuous appeal rendered it fundament-
ally acceptable as a medium to Atkinson. Here form at its
purest would lie to his hand, offering the opportunity of
creating shapes which would become ideas under his work-
manship.

His first experiments were, as might be expected, not a full fruition of the philosophy which was governing his art progress. At the beginning this three dimensional medium of clay or stone offered itself chiefly as an opportunity of expressing the essential elements conveyed to him by the surface of things. This phase, short-lived as it was, (for Atkinson moved rapidly on to the more important aspect of his sculptural work) is important as revealing the growth plastically of those beliefs which elsewhere we saw operating pictorially.

The illustration "In the Beginning" the best known of the pieces of this kind will show the attitude of the artist during this period. One notes the interesting treatment of the head as a mask beneath which the accidents of personality are sacrificed in order that the more general idea may be expressed. This fact of the mask may still serve as a parable of the æsthetic philosophy of the artist before his work passed right across to the Pure Abstractionism. In a world where the function of the theatre is so debased that its art-value is but little higher than that of the personality-mongering of the music halls we are forgetting the way to use masks. The Greek world, however, and that great Eastern world wherein art is anonymous and impersonal, being too universal to be limited by personality, understood the need of rendering the individual actor transparent so that the dramatic idea should not be blurred in transit. The mask which the actor wore was thus intended on the one hand to conceal the irrelevancies of personality, and on the other, by dexterous use to intensify the intention of the dramatist. It was moreover a symbol understood immediately by the people, so that every mind in those vast audiences would re-act

"IN THE BEGINNING"

Sculpture in Stone

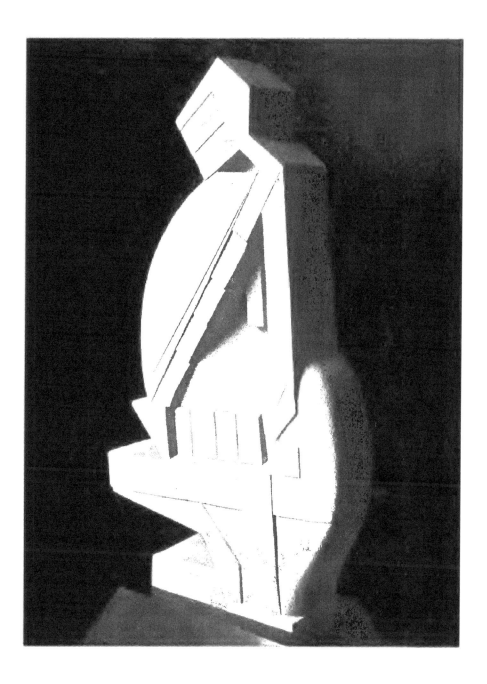

subconsciously without any stressing of the faculty of mere reasoning towards the actor's basic meaning. Thus the mask served the purpose of art by clarifying, by universalising, by symbolising. It removed from the artist's path the dangerous and confusing factor of individuality and gave in its place the pure matter of art, expressed through the medium of a symbol of universal acceptation.

It is precisely this desire which accounts for so many of the tendencies of modern art. The tragic motive of the sculpture which Atkinson calls "In the Beginning" was more perfectly conveyed by sheer pose of mass and the patterned lines which accentuate the droop of the head, than by any individualised subtlety of facial expression. Nor does this method cease with the treatment of the head; it is extended to every part of the study. The whole figure becomes a mask expressing the strength of animalism rendered pathetic at the strange incoming of the new force of thought. No realistic rendering of Pithecanthropus Erectus could better achieve the purpose.

As with the paintings it was the logical pursuing of the philosophy implied by this method which led Atkinson to the purely abstract form of his art. He realised that emotions and ideas were conveyed not by things in themselves, but by the lines and masses inherent in things. Thus in dancing, the human figure can become a veritable language of human thought and emotion because it can arrange and rearrange its lines and masses to the conveying of such. Much of our sub-conscious sense of the signification of such lines, indeed, comes from the association with certain poses and gestures of the human body, although doubtless were we to analyse those poses and gestures we

should find that they themselves referred back to some inexplicable and innate sense of fitting form within us.

But however and wherever this sense of fitting form came, whether physically through man's contact with the material world, or psychologically through his religious sense ; or, as is most probable, through some admixture of the two, its existence in the consciousness and the subconsciousness of man cannot be disputed. Recognition of this intrinsic power existing in form caused us to ascribe to non-sentient objects those qualities which their lines suggest to us, as for example when we speak of the weeping willow because the lines of the tree suggest to us those lines associated with grief.

As with the paintings, so with this more essentially formistic art of sculpture, Atkinson after a time abandoned the use of objects even to suggest the lines which were his fundamental medium, and sought to convey ideas and emotions by a pure use of such lines. In the three dimensional art he relied, as he had done in the paintings, upon his own subconsciousness in making his images, and created straight from the inmost parts of his own mind, pieces which conveyed his intention by sheer structure and line and mass relationship. His art became in sculpture, as in painting, a concrete expression of abstract ideas and not an abstract expression of concrete things. The difference of method and æsthetic belief has to be clearly understood if the latter forms of art of such an artist as Atkinson are to be really appreciated. The difference between simplifying an object down to its essential lines and masses, and building up a work of art by the use of lines and masses having their own significance is a very great one. In the first instance it becomes almost certainly necessary for the onlooker to establish the association

" EVASION "

Sculpture

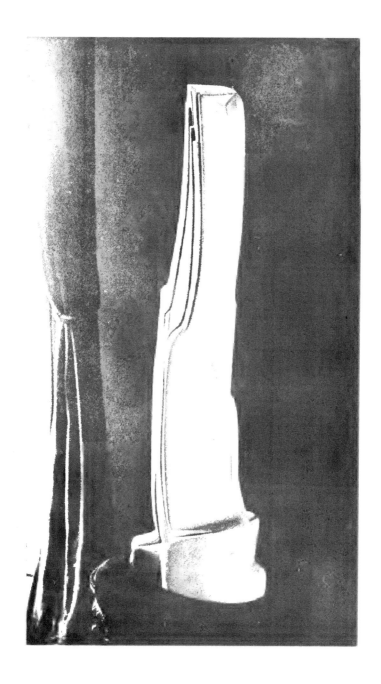

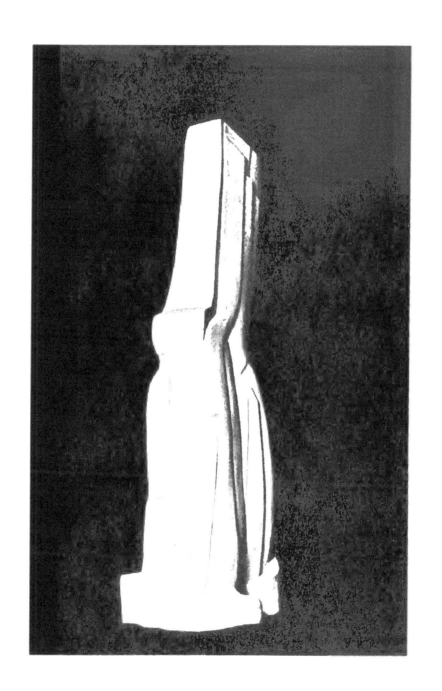

with the thing itself, whilst in the other, any attempt to find a correlation of material form is fatal to the artist's intentions and utterly misleading. Often, indeed, it may be said that this kind of art fails because the composition of the purely abstract lines expressing abstract thought bears some accidental resemblance to some object in the world of material phenomena, and the mind of the onlooker is thus led astray and finally held fast by a false representation. The danger is particularly strong to people whose whole artistic interest is in representational work, and whose minds lack the power of comprehending abstract or psychic facts. Such untrained minds will always be seeking an approximate resemblance to something in the visual world, whereas the mind trained to the understanding and the appreciation of the abstract will often be enabled to dissociate this quality of linear and mass significance from the common objects of everyday life and from works of art which are apparently representational. Thus an artist may see his work æsthetically as " an arrangement in brown and silver," as Whistler called the " Portrait of his Mother," being concerned with it simply as an artistic creation and expressing publicly his amazement that anyone other than himself and personal acquaintances should be interested in the identity of the model. In this attitude toward the essential elements of his art Whistler reveals himself as being on the way to the art of our own day, and it was this beginning of the attempt at a new valuation in art which accounts for the failure of the people of his day to appreciate his aims and their result.

The departure to absolute abstraction in sculpture by Lawrence Atkinson was also from the viewpoint of one important tenet of his æsthetic philosophy, a return to nature. He realised that the creative forces of nature working through

different media were always governed as to form by the nature of
the material in which they were working. He realised that in
the reaction which things have upon our minds we were prone
to see an unity of idea between things and shapes utterly different
because we accepted this important factor of the substance of
the material involved. Thus Atkinson working out his ideas in
clay or stone, or at a later period in wood or metal, allowed the
qualities peculiar to his material to help him in expression. He
created as he felt nature would create if she were dealing with
such material, and if the surfaces were subject only to such forces
as he was personally concerned with. Ruskin in one of his art
treatises argues that in making an exact drawing of some natural
object the artist will reveal its whole history with relation to its
environment. If the artist's purpose is this, it were well that he
should strive for this result, but when we have changed the basic
intention of art it becomes necessary to clarify every irrelevancy
away in order that our fundamental intention may be the more
clearly revealed. To such an artist the history of environment
will probably be entirely irrelevant and the factor of material
must only be allowed to intrude as a contribution to the artist's
ultimate aim. Here again the belief in the power of the sub-
conscious stood Atkinson in good stead. He allowed his material
to assist in the dictation of the form necessary ; and when he
began thus to trust the matter in which he was working, and to
create, as he would say, in nature's way if she were using clay
instead of other matter, his sculpture took upon itself a difference
from the pictorial work which was governed by a like
philosophy. The geometrical forms which seemed right in
graphic art gave place to what I have called " significant
amorphism." One sees a reaction from this in the later low
reliefs in stone where the medium again demanded that element
of geometrical structure but to me the most interesting period of

ALOOF

Sculpture in Polished Wood

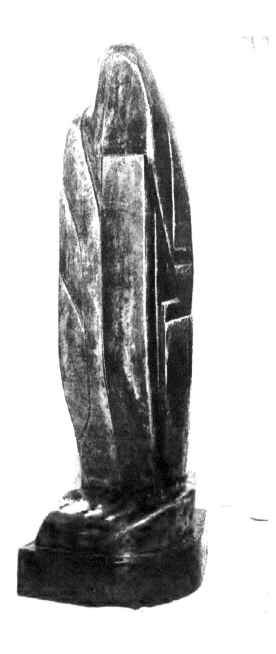

the sculpture is this one of almost amorphous, comparatively simple shapes which came into being to express ideas and emotions of their creator and which he believed to be inherent in just those shapes and conveyable to other minds through them. One thinks for example of the work called " Aloof." It needs no outside reference to convey to us the feeling which the piece gives : the lines evade one, they turn in upon themselves, they seem to meet somewhere inside, somewhere away from the beholder, they twist higher and lose themselves in some intricacies which one cannot quite analyse. It has a curious Egyptian feeling as though it held some knowledge just beyond our reach. Worked out in polished black wood on a base of vivid green it comes to us with the thrill that some beautiful symbol of an unknown religion might bring. It has a personality, a life of its own, and a meaning half conveyed to us in its intrinsic line structure. For in this case it is not the artist's intention that the whole should be revealed ; the charm of the piece is that it retains its secret. Such another piece as " The Memorial " likewise depending for its means of expression upon amorphic form, yet achieves its result by other means. It is because here the emotion meant to be conveyed is a less remote one that the material chosen is stone with its hardness, its objectiveness. Atkinson here wished to express grief, but grief triumphant, grief proud because it realised that life's eternal purpose was greater than the personal grief for the departed. It was indeed a conception which grew out of the desire of the artist to add his quota of expression of grief for the fallen. Several of the pieces designed at this time were designed as cenotaphs, wherein Atkinson used his abstract forms for such expression. We have tended to realise that neither the pictorial realistic sculpture which has for so long tyrannised our public places as monuments, nor the use of a purely Christian symbology which seems scarcely wide enough to

cover our growing religious conceptions, can adequately express
the deep things of the emotions which are our heritage from the
European War. We have in places attempted to achieve the
necessary breadth and significance by the erection of architectural
units and in so far that they freed the mind from the confines of
the realistic and from the set of intellectual ideas centred upon
Christian doctrine one realises their value in fulfilling their pur-
pose as memorials inspired by the growing consciousness of our
day. Their failure, however, lies in their comparative barren-
ness. It is an obvious next step to use the expressive power of
some such abstract art as this of Lawrence Atkinson to convey in
lines and masses of universal appeal an emotion which is in itself
universal. One wonders how long the innate conservatism which
is so essentially an English characteristic, especially in regard to
matters of art, will stand in the way of the taking of this next
step.

The sculpture of Lawrence Atkinson now constitutes the
considerable body of his work. His drawings and paintings in
these days tend to be not so much ends in themselves as the fore-
shadowings of plastic art, worked out in the quicker medium so
as to snare the ideas. These sketches and elaborated designs for
sculpture may be in themselves interesting, but to Atkinson their
final shape in stone, metal or coloured wood is the centre of
interest.

Occasionally he makes use of colour in achieving his effect,
emphasising the planes or masses by this means. With the in-
creasing abstraction of his work, however, this method tends to
disappear save in the choice of pieces of stone of beautiful self-
colour. The pieces designed for wood still tempt the artist to the
somewhat extraneous aid, and although to my mind plastic art

has followed a perfectly right evolution in dispensing with applied colour, yet it has to be admitted that some of Atkinson's experiments in this way are successful.

For an artist with Lawrence Atkinson's versatility the course of his work might lead in almost any direction. His model for a music room shown at his recent Exhibition hints one possibility, and it would be an interesting forward step in interior decoration if he were allowed to carry out such a scheme in the fine marbles, woods and stones which he has projected. His low reliefs, too, which called to mind the influence of music upon his art, were among the most beautiful things he has achieved. Whatever line he works upon it can be depended that he will follow consistently the trend of the mind which has led him away from representational art into this deeper region of the abstract in paint and stone. Whatever work he produces will be called into being at the dictates of his own creative necessity. In that faith we may wait.

Lightning Source UK Ltd.
Milton Keynes UK
UKHW021839130223
416874UK00005B/755